Giorgio Bonsanti
Director of the Gallery

D0746544

The Galleria della
Accademia
Florence

Guide to the Gallery and Complete Catalogue

Becocci/Scala
in collaboration with the Coop. "Lo Studiolo" of the "Amici dei Musei Fiorentini"

Contents

PRIMO PIANO

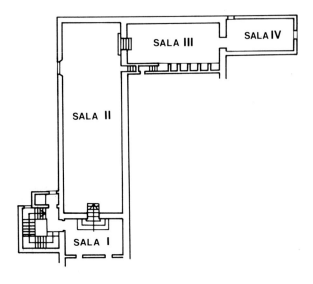

PIANO TERRA

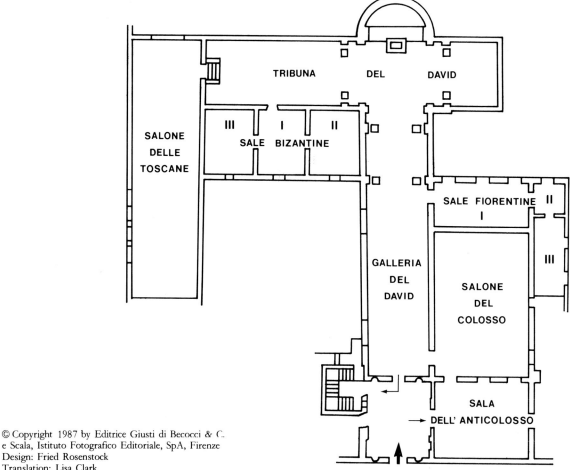

© Copyright 1987 by Editrice Giusti di Becocci & C.
e Scala, Istituto Fotografico Editoriale, SpA, Firenze
Design: Fried Rosenstock
Translation: Lisa Clark
Photographs: Scala (Nicola Grifoni)
Printed by Lito Terrazzi, Cascine del Riccio (FI) 1992

Introduction

Probably not many of the visitors going to the Galleria dell'Accademia, at no. 60 in Via Ricasoli (the former Via del Cocomero), know the full meaning and the origin of these two words, Gallery and Academy. The term Gallery, which became widely used only in the nineteenth century when constructions designed specifically to house museums were built throughout Europe, was originally used to describe the top floor of the Uffizi: a very long corridor (the word itself is derived from the medieval latin "galilaea," meaning portico) with the rooms opening off it. This inspired architectural design was the work of Giorgio Vasari, whom the Medici had called upon when they decided to set aside a floor of their new palace as a permanent exhibition of their works of art. But the definitive affirmation of the word Gallery happened in the following century, with the collection in the "Grande Galerie" of the Louvre, inaugurated in 1681, which became during the French Revolution the first Museum for the People and was proclaimed Museum of the Republic. In London, Dresden, and later Washington, many other museums were built and to this day still define themselves "Galleries."

The term Academy, on the other hand, comes from classical Greek. It designated an area in northwestern Athens, which took its name from its former owner, Academos. On the land there was a large park, where Plato lectured on philosophy, conversing with his disciples while walking through the trees. The term Academy thus came to mean the Platonic school, which continued to function as an institution of learning even after the philosopher's death. Over the centuries the Athenian Academy lost its prestige, but all in all it survived for more than nine hundred years, until 529 A.D. when the Edict of Justinian decreed the suppression of all philosophical schools. When, during Humanism, there was a renewed interest in classical antiquity, the term Academy became once again very widely used. The first Art Academy was the one founded by Giorgio Vasari, with the patronage of the Medici prince, in 1563. The Accademia del Disegno (of Drawing), as it was called, was for two centuries the most important institution that contributed to the theoretical codification of the rules of Florentine art. The most successful artists belonged to this Academy: to be a member was a sign of prestige and great honour. But over the years its role as a teaching institution had died out, and in 1784 it was radically reformed by Pietro Leopoldo of Lorraine (the dynasty that had succeeded the Medici). The Accademia delle Arti del Disegno remained, but its functions were now limited, and it became simply a meeting place for established artists. Pietro Leopoldo founded the new Florentine Academy, based on the two principles that still stand today: its role as a teaching institution and its possession of works of art from which the students can learn. The Academy of Fine Arts was to be an efficient art school, for it was a general belief that art can be taught and learnt. Today we tend to think that art cannot be taught; but one can doubtless teach artistic techniques. And the possession of works of art was important because at the time the foundation of artistic training consisted in systematic and repeated copying of the great masterpieces of the past, the works of artists who had lived centuries earlier.

For this reason, Pietro Leopoldo set up a collection of paintings of great importance, to be used as models by the students. Most of the paintings came from the early Medici collections; others from suppressed religious institutions and the secularization of ecclesiastical property, a practice that became quite common again during the Napoleonic period and after the Unification of Italy. The Academy was housed, and still is today, in that extraordinary architectural complex that assembles under the same roof the

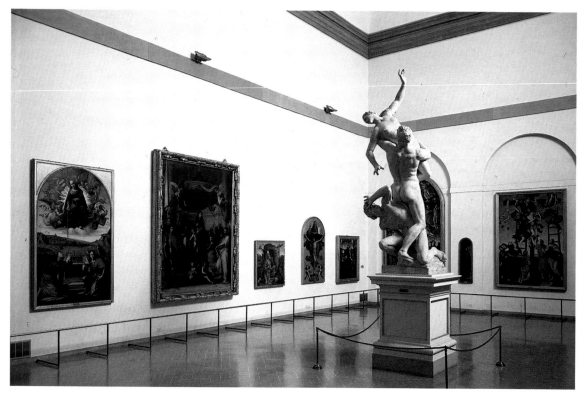

The "Salone del Colosso"

The Tribune of the David ▷

Accademia di Belle Arti, the Galleria dell' Accademia, the Music Conservatory (now named after Luigi Cherubini), the Opificio delle Pietre Dure, founded by the Medici. It was primarily two earlier constructions that were restored and renovated to create the new architectural complex: the fourteenth-century Hospital of St Matthew and the convent of the nuns of St Nicholas of Cafaggio.

The "Description of the Imperial and Royal Academy of Fine Arts of Florence," drawn up in 1817 by Carlo Colzi, contains precious information not only on the works of art housed in these buildings (which were such that ". . . visitors come in great quantities to admire the beautiful and precious objects"), but also on the internal organization of the buildings, even though an exact reconstruction of the various exhibition rooms is extremely difficult for Colzi provides no ground-plan. And we learn that there were no real internal divisions, and that one could go directly from the "Gallery of Small Paintings" or the "Gallery of Paintings," which contained the largest number of works and was also known as the Galleria di Mezzogiorno or Southern Gallery, to the rooms where various instruments were taught, such as the violin, the organ or the piano, or the room of singing and the room of counterpoint. Two cloisters were also considered part of the Accademia: the Chiostro dello Scalzo, on today's Via Cavour, and the Chiostro dei Voti, next to the church of Santissima Annunziata. Among the paintings that hung in the Southern Gallery many can be identified still today: most of them are now in the Uffizi, but some have remained in the Accademia and a few, in particular those by Fra Angelico, are now in the Museum of San Marco nearby.

In 1873, the "Schools Inspector" Jacopo Cavallucci drew up a "Historical survey of the galleries of ancient and modern paintings in the Royal Accademia delle Arti del Disegno in Florence," addressed to the Director of the Academy of Fine Arts, Cavalier Enrico Pollastrini, on behalf of the Minister of Education. Cavallucci records that in 1841 the then President, Antonio Ramirez di Montalvo, reorganized the paintings, placing them in chronological order and had

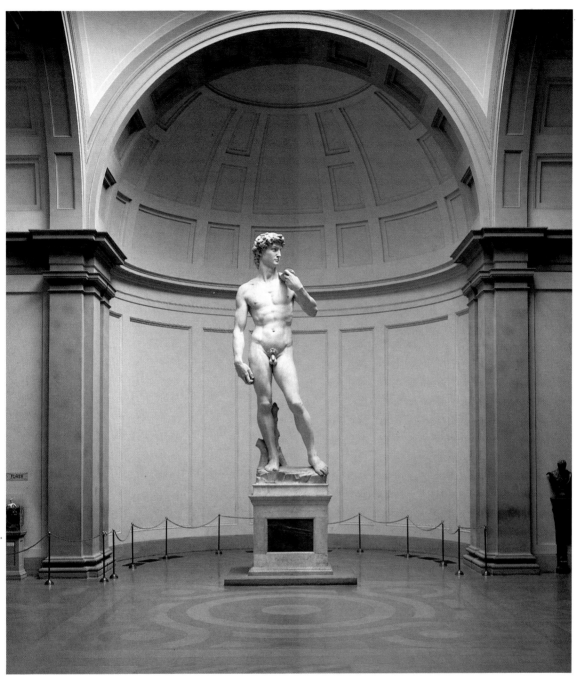

some new windows opened to improve the lighting. In Cavallucci's time the Gallery exhibited 260 paintings and 24 cartoons, housed in two large rooms and two small ones. The first large room was the room that today houses the works dating from the nineteenth century, Salone delle Toscane, and was originally a part of the Hospital of St Matthew: it contained the most important paintings. The paintings exhibited in the second large room were intended to illustrate the progress and development of art, from the earliest examples to the Renaissance. One extremely interesting piece of information that this survey provides is that works considered of minor importance had not been touched by the restorers of the time, all too often responsible for the terrible condition of paintings. Cavallucci also defined the character of the Gallery, which was by then firmly established: "The painting collection at the Academy, although it cannot compete with the collections in the Pitti Palace and in the Uffizi ... is quite

rightly held in the highest esteem, not so much for the intrinsic merits of the individual paintings as for the importance that each one has in the overall history of art." The author ended his survey with a mention of the two Galleries of modern paintings: the "Premiati" (or prize-winners), which were the work of the best students in the competitions held every three years, or annually amongst the students awarded scholarships, and the Gallery of Modern Paintings, annexed to the Academy in 1866, which comprised works bought by Grand Duke Leopoldo II or by the Government. Entrance was free, and the Galleries were open from 9 a.m. to 3 p.m. every day except holidays.

In 1882 the Direction of the Gallery was transferred from the Institute of Fine Arts to the Direction of the Royal Galleries and Museums; it was at that time that it was given its present entrance, through rooms that had previously belonged to the Opificio delle Pietre Dure. The guide book by Eugenio Pieraccini, published in 1884, describes all the works of art and their positioning in the various exhibition rooms, also providing a useful ground-plan. But above all it records the great novelty of the time, the construction of the Tribune for the *David*, designed and built by architect De Fabris in 1882, when he was Director of the Academy of Fine Arts. Michelangelo's famous statue, which soon became the symbol of the Gallery, had been transferred here in 1873 from its position in front of Palazzo Vecchio where it was afforded no protection from the elements. The transportation took place at night and in the early hours of the morning (to avoid the heat of the day) between 31 July and 4 August. Engineers Porra and Poggi had designed a special wooden waggon in which the statue hung, upright, so as not to be damaged in transport. The original model, on loan from the Casa Buonarroti, Michelangelo's house, is today on exhibit to the left of the sculpture.

In 1909 five more sculptures by Michelangelo joined the *David* at the Academy: the four *Prigioni* (Prisoners or Slaves) and the *St Matthew*. (The *Palestrina Pietà* arrived in 1939). The Gallery and the Tribune were lined with famous tapestries and a large number of plaster casts of sculptures by Michelangelo in other Italian cities were placed along the walls, according to the didactic criteria then in vogue. In the years following World War I a first exchange of works of art with the Uffizi took place; after the second exchange had been arranged, all the important fourteenth-century works ended up in the Uffizi, Florence's most important Gallery. It is for this reason that today the most famous paintings that hung, at one time or another, on the walls of the Accademia are all at the Uffizi: Botticelli's *Primavera* or Allegory of Spring, Leonardo and Verrocchio's *Baptism of Christ*, Cimabue's *Maestà*, Giotto's *Ognissanti Madonna*. Fra Angelico's paintings, on the other hand, were all transferred in 1922 to San Marco where the new museum was set up.

In the 1950s Luisa Marcucci re-organized the paintings dating from the thirteenth to the fifteenth centuries; in 1976 Luciano Bellosi restored and re-organized the large room known as Salone del Colosso. The alterations carried out by the present administration, begun in late 1983 and completed before the re-opening to the public on 22 June 1985, have followed well-defined criteria. On the one hand, we were concerned with the protection of the works of art, which is why the tapestries were removed, since their preservation is jeopardized by constant exposure to light and by the traction exerted by their own weight when hung. On the other hand, it was our intention to underline the principle which we have seen had already been recognised in the nineteenth century: that the Galleria dell'Accademia offers a documentation of works of art that are by no means second rate, and which illustrate the rich and complex cultural background out of which are born the so-called major works of art. In the new rooms on the first floor, which had never been used before, there is a wide range of Florentine paintings dating from the late fourteenth century and the first half of the fifteenth, which, together with the Lorraine collection of icons, makes up one the most outstanding collection of "gold

The large room on the first floor

backgrounds" in the world. On the ground floor, the large room called Salone delle Toscane houses the collection of original plaster models by Lorenzo Bartolini, who was a teacher at the Academy in the nineteenth century but was also one of the most popular European sculptors of his time. In this room there are also the plaster models of another of the Academy's teachers, Pampaloni, as well as paintings that won competitions and paintings by the Professors of the Academy: a historical link between the Accademia of the past and today's. Now that the paintings of the sixteenth-century schools have replaced the tapestries in the Tribune near the *David*, the Galleria dell'Accademia is no longer simply the "Gallery of the David," as it had unfortunately become in the eyes of the majority of visitors; it now offers the best example of a collection of Florentine schools of painting from the late thirteenth century through to the sixteenth. The value of the Academy as a training centre and as a collection of works of all the major artistic trends over the course of the three greatest centuries in the history of Florentine painting is thus re-affirmed; today the Gallery presents itself to the public with totally new characteristics. As far as the public is concerned, the enormous numbers of visitors which we have become used to over the past few years has forced us to plan protective elements which certainly do not improve the visibility of the works of art. We hope that in the near future a greater degree of maturity and responsibility on the part of the public will allow us to remove some of the barriers we have been obliged to set up, so that the contact with the works of art can be more direct and immediate. Then the *David* will stop being the object of fetish it is at the moment and become once again a great work of art, to be studied with a fresh mind and admired with new interest.

"Salone del Colosso"

Nowadays the entrance to the Galleria dell'Accademia is through a large vestibule that was once part of the Opificio delle Pietre Dure. A recent alteration to the entrance door has separated the exit from the entrance, making access to the Gallery much easier; it is now also possible to close off the entrance temporarily when the Gallery is too crowded, and only re-open it after a sufficient number of visitors has left. From the vestibule one goes into a room to the right, called the "Sala dell'Anticolosso," since it is the room before the "Salone del Colosso," given this name in the nineteenth century when it housed a full-scale plaster copy of one of the Dioscuri (Castor and Pollux) from Monte Cavallo in Rome. Although in the past the "Sala dell'Anticolosso" was used as an exhibition room, housing the large sixteenth-century canvases now in the Tribune, it has recently been transformed into the ticket office, since the increasingly large number of daily visitors called for more space for these operations. The entrance proper to the Gallery is thus in the "Salone del Colosso." Today the copy of the huge statue from Monte Cavallo is no longer in the centre of the room, but, thanks to the intelligent arrangement devised several years ago by the former Director, Luciano Bellosi, we can see the original plaster model of Giambologna's *Rape of the Sabine Women* (the marble sculpture is in the Loggia dei Lanzi in Piazza della Signoria). Until 1980 the Gallery also had another large plaster model by Giambologna, the model for the marble group showing *Florence conquering Pisa*, now in the Bargello; on the occasion of the Medici exhibitions held that year, the statue was lent to Palazzo Vecchio, where it still stands, in the huge Salone dei Cinquecento, in the same position originally occupied by the marble sculpture.

These large models, made out of a whole variety of materials (clay, tow, stucco; we call them plaster to simplify), were the ori-ginal full-scale studies that the artist made after he had done his reduced scale models, but before setting to work on the block of marble. We shall see below, when dealing with the "Salone delle Toscane," how in a way they can be considered to be even more "original" than the definitive sculptures. The *Rape of the Sabine Women* is a three-figure

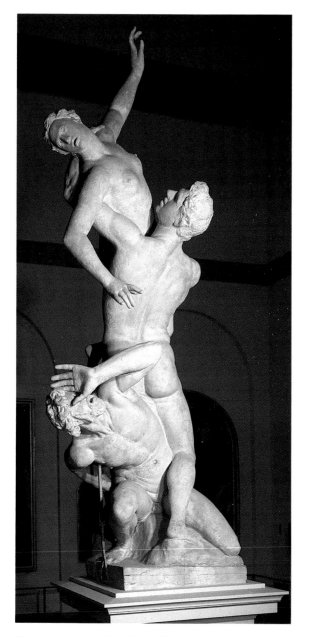

Giambologna: Rape of the Sabine Women

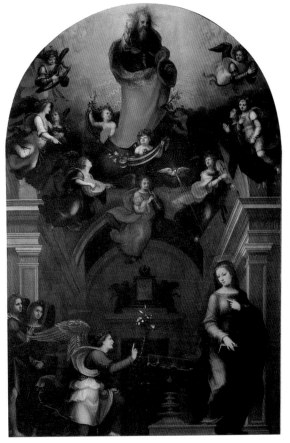

Francesco Granacci: Madonna in Glory with Saints

Mariotto Albertinelli: Annunciation ▷

group which originally was not meant to portray any specific event. Giambologna (Jean de Boulogne, actually born in Douai in Flanders in 1529, arrived in Italy probably around 1554 and stayed in Florence where he died in 1608, having become famous throughout Europe) had carved this group in 1582 to prove that he was able to produce large scale stone works and not just bronzes. His aim was to "show the excellence of his art . . . and, without referring to any story in particular, he created a proud young hero snatching a beautiful maiden from a weak old man" (Borghini). And in fact it was Borghini himself, a man of letters of the time, who suggested the title *Rape of the Sabine Women*. The intention of the artist, which can be understood just as clearly from the model as from the marble statue, was to create a study in difficulty. The figures are laid out vertically in a series of spiral curves, carefully calculated, and rhythmically emphasized by the torsion of the limbs. The woman's oustretched arms and the old father's pleading arms are exam-

ples of this and are as emblematic of the mood of the sculpture as the distraught faces. This is one of the best examples of the virtuosity attained at its best by Mannerist sculpture.

The room also contains an extraordinary documentation of early sixteenth-century Florentine art. Here we find works of famous artists of the period, such as Perugino, Filippino Lippi and Fra Bartolomeo; but the main characteristic of the works collected here (and, indeed, of the whole Gallery) is that they document, with examples that are culturally of primary importance, the production of the current Florentine trends as well as the lesser but more numerous artistic expressions, without which the major achievements would appear to be of diminished importance. Artists such as Granacci, Bugiardini, Ridolfo Ghirlandaio, Sogliani, Albertinelli may never become truly popular; but a discerning and unprejudiced study of their work often reveals unsuspected gems of intelligence and artistic achievement.

9

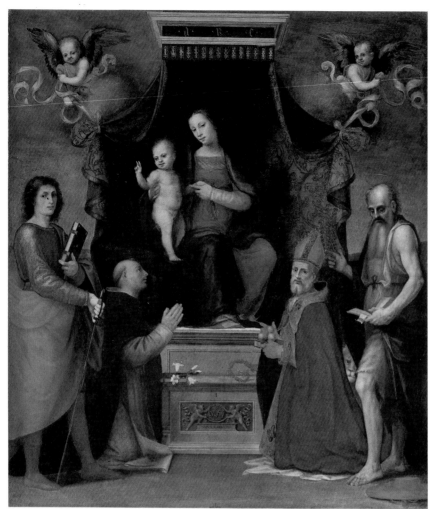

Mariotto Albertinelli:
Madonna and Child with
Saints

▷
Girolamo del Pacchia:
Madonna and Child with the
Young St John

▷▷
Filippino Lippi: St John the
Baptist and St Mary Magdalen

Francesco Granacci, who was born near Florence around 1470 and died in 1543, is known above all for having been an apprentice together with Michelangelo (who was five years younger) in Ghirlandaio's workshop; throughout his career he tried to keep in touch with Michelangelo's great and complex art. Critics have pointed out how his attempts to create monumental figures never really succeed: his figures swell and expand, but never become truly "great." Among his paintings exhibited in this room, firstly, just next to the door leading to the Gallery, the *Madonna of the Girdle* from the church of San Pier Maggiore: iconographically a fairly popular subject, it shows the Virgin, at the moment of the Assumption, leaving her girdle (really a sash or belt) to the ever Doubting Thomas. To the right, St Michael kneeling, looking out at the spectator; at the centre, the empty grave

covered in flowers. The painting dates from 1508-9, when Fra Bartolomeo had introduced a new classical style to Florentine painting. This work of Granacci's shows how he had already fully converted to a sixteenth-century classicism, which Freedberg has called "minimal" (1961): in other words, in no way comparable to the grander art of Fra Bartolomeo, but equally innovative. Notice the gold rays around the Virgin's head, an archaic element that underlines her holiness.

Also by Granacci, but dating from a few years later (c 1515), is the *Madonna in Glory with Saints Bernardo degli Uberti, George, John Gualberto and Catherine*, from the church of San Giorgio sulla Costa. It hangs on the wall opposite. Here the attempt to imitate Fra Bartolomeo's monumentality is even more obvious, as is the influence of the Florentine works of Raphael, such as the

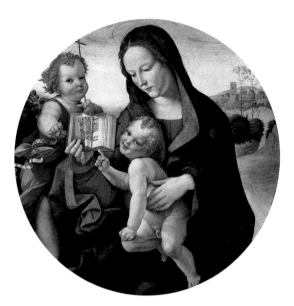

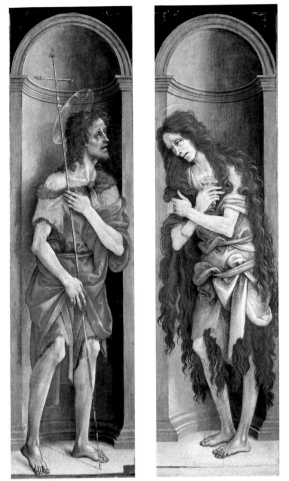

Madonna of the Canopy in the Pitti Palace. Undoubtedly there is still a certain artificiality: the figures' gestures possess neither ease nor naturalness. The heritage of his fifteenth-century training remains obvious in his difficulty to integrate his attention to detail into a broader message; even the carefully executed details are not entirely convincing.

On the lefthand wall, next to the first Granacci, is a very important painting: the grandiose *Pitti Altarpiece* as it is normally referred to, painted by Fra Bartolomeo. It shows the so-called *Mystic Wedding of St Catherine* (notice that the child Jesus is placing the wedding ring on her finger), that takes place amidst a crowd of saints. It was painted in 1512 for the church of San Marco; in 1690 it was transferred to the private apartment of Prince Ferdinando de' Medici in the Pitti Palace. At the Uffizi since 1919, it joined the collections at the Accademia in 1954. Among what Vasari called "the infinite number of figures," one can identify St George, on the left, and St Bartholomew, to the right, recognizable from the knife used to flay his skin. Vasari mentioned the influence of Leonardo in the artist's use of a prevalently dark palette, and also pointed out his attempts at three-dimensionality in the figures and at spatial depth. In fact, the artist Fra Bartolomeo (Baccio della Porta, born and died in Florence, 1475-1517, ordained Dominican friar

in 1500) is acquiring an ever greater importance as the work of modern scholars on the Cinquecento succeeds in shedding more light on the extremely complex developments of the first two decades of the century. In particular, Fra Bartolomeo's studies of spatial depth are now seen to have been of the utmost importance in the development of Raphael's style during his Florentine period, from 1504 to 1508. The Dominican friar's art epitomizes a very important and progressive tendency, striving towards a monumental style, a style in which the figures would be much larger while at the same time their relationship with the space around them—not limited by the boundaries of the painting—would become more realistic.

In the *Pitti Altarpiece* the space of the painting takes on a wide circular movement; the surface acquires a third dimension, and the flying angels supporting the canopy are balanced by the shape of the niche and the

11

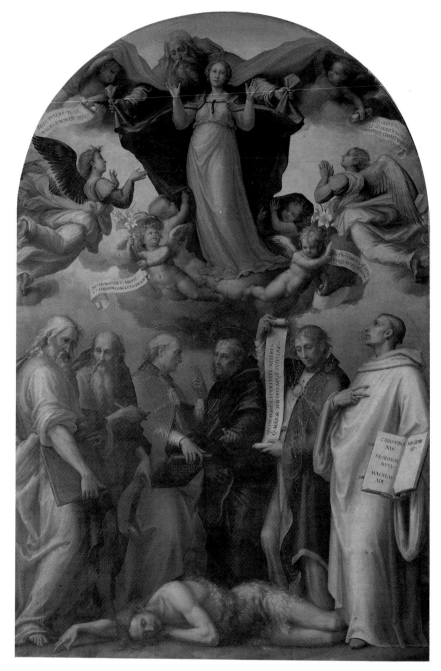

Francesco Botticini: St
Augustine

Giovanni Antonio Sogliani:
Disputation over the
Immaculate Conception

extremely precise arrangement of the saints.
All in all, it is one of the most important
paintings in Western art of that time, which
also shows some of the novelties Fra Barto-
lomeo had come in contact with during his
earlier trip to Venice, where he had seen
Giovanni Bellini's large altarpieces.

On the end wall the two niches at the left
and in the centre contain two paintings that
are almost entirely the work of Pietro Peru-
gino. The comparison with Fra Bartolo-
meo's altarpiece, examined above, shows

what an enormous development had taken
place in the ten years that separate them.
The large panel to the left, from the church
of the Abbey of Vallombrosa, is signed and
dated 1500. Below the Virgin, who is
turned towards God the Almighty, there are
four saints who were closely connected to
the Camaldolensian order: from the left,
John Gualberto, Bernardo degli Uberti,
Benedict and Michael. But the extremely
crowded composition could be that of an
enlarged miniature; the space is like a

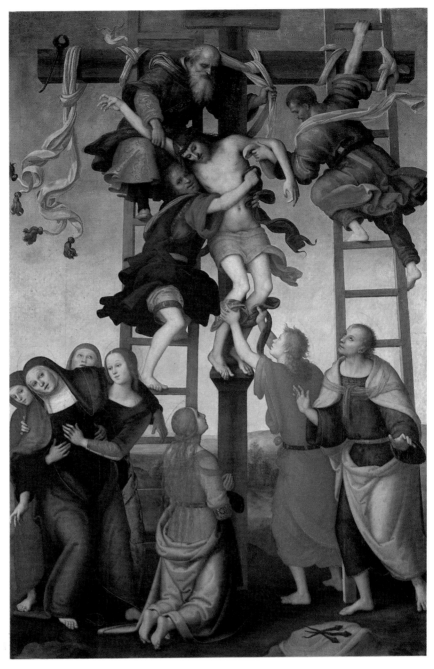

Perugino and Filippino Lippi:
Deposition from the Cross

boundless backdrop, against which the figures are lost and unable to find their own identifiable position. So that the only positive qualities of the painting are the celebrated grace and harmony of Perugino (Pietro Vannucci, Città della Pieve c 1448 – Fontignano 1523).

The other large painting by Perugino, the *Deposition from the Cross* at the centre of the wall, is very interesting, even though Perugino only began work on it after Filippino Lippi, who had begun it, died in 1504. The painting was intended for the high altar of the church of Santissima Annunziata. It was quite a grand project, including very elaborate wooden frames, a painting on the verso (an *Assumption*, still in the church) and a series of other figures, now scattered in various collections. Filippino probably only painted the four figures at the top, which were in any case retouched by Perugino either because they were unfinished or in order to uniform them to the rest of the figures. The figures in the lower part of the

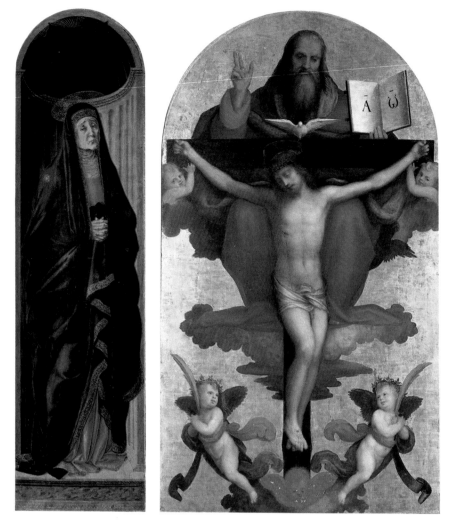

◁
Francesco Botticini: St Monica

Mariotto Albertinelli: The Holy Trinity

painting also do not appear to be totally the work of Perugino, except for the one to the right. It has been suggested that the young Raphael may have have taken part in the work, since he was in Florence that year. We think that it is likely that he worked on Mary Magdalen and St John, both of much higher quality than the group of Holy Women to the left. In any case, all the daring and innovative elements in the painting (such as the group at the top) are the work of Filippino, an extremely interesting artist (see the two paintings of *Mary Magdalen* and *St John the Baptist* on the righthand wall).

The third large painting on the end wall is also very interesting: a *Disputation over the Immaculate Conception* by Giovanni Antonio Sogliani (Florence 1492-1544). Sogliani is a much more interesting artist than is usually considered, even though his training in a conventional and old-fashioned workshop (under Lorenzo di Credi) conditioned his work for a very long time. This painting comes from the church of the nuns of San Luca in Via San Gallo and can be dated around 1520; it confirms Sogliani's ability to deal with innovative and complex iconographies. Adam, the cause of Original Sin, lies on the ground; around him, Saints John the Evangelist, Jerome, Augustine, Gregory, Ambrose and Bernard; above, the Virgin of the Assumption. The scrolls held by the angels and other figures suggest the Mystery of the Immaculate Conception. Vasari stated that the heads of the figures were the "best" Sogliani ever painted; certainly the overall result is of extremely high quality and, in many details, the pictorial technique is fascinating.

On the righthand wall there is the large panel of the *Annunciation* which belonged to

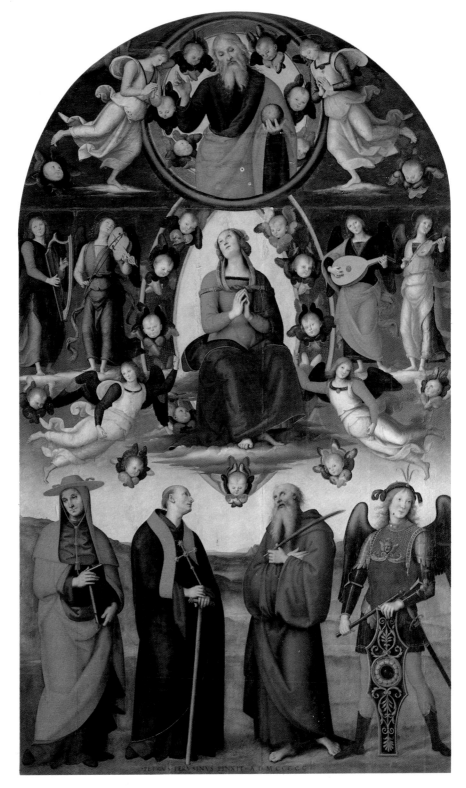

Perugino: Assumption

the Company of San Zanobi and stood in the chapterhouse of Florence Cathedral (Santa Maria del Fiore). It is signed and dated on the lectern: *1510 Mariotti florentini opus,* for it is the work of Mariotto Albertinelli, another important Florentine painter (1474-1515), whose artistic career is closely bound to that of Fra Bartolomeo. Before the latter took his vows, the two young artists actually worked together in a partnership; and later, from 1509 to 1513, they shared a workshop again. His style appears

15

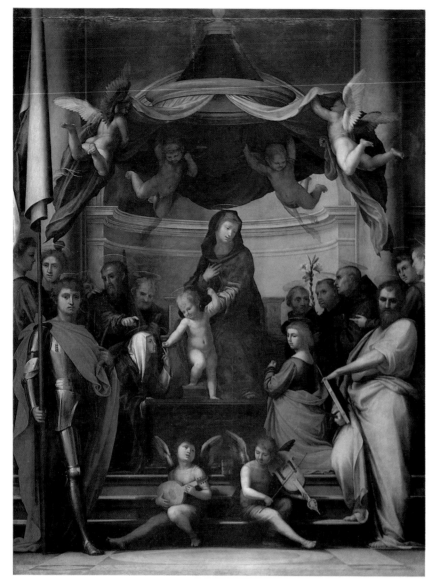

Fra Bartolomeo: Pitti
Altarpiece

almost to be the result of the same research and development as that of Fra Bartolomeo, so much so that it is often difficult to distinguish their work, especially in paintings on which they collaborated. Generally speaking, Mariotto's work is a step below the noble grandeur of Fra Bartolomeo, and his style is more fragmented. But in any case his ability was remarkable and this painting stands out among contemporary achievements. The precious gold decoration in the angel's wings and in the flower garland is splendid, but the qualities of the work are not to be found only in details like these: the architectural construction, daringly foreshortened, is admirable. This startlingly vertical movement is balanced by the circular setting of the group of angels, which gives a sense of action even though each figure is quite restrained. All in all it is a splendid painting, one of those that should make the artist well known if not famous.

in the centre of the room:
Jean de Boulogne called
Giambologna
(Douai 1529-Florence 1608)
The Rape of the Sabine Women
Inv. no. 1071

Fra Bartolomeo della Porta
(Baccio della Porta)
(Savignano di Prato
1475-Florence 1517)
The Prophet Isaiah
Wood, 168x108 cm
Inv. no. 1448
From the Billi Chapel in the
church of Santissima
Annunziata in Florence.

Francesco Granacci
(Villamagna 1469/70-Florence
1543)
Madonna in Glory with Saints
Wood, 301.5x217.3 cm
Inv. no. 8650
From the church of San Giorgio
sulla Costa in Florence.

Francesco Granacci
Madonna and Child with Saints
Wood, 192.5x174 cm
Inv. no. 3247
From the Girolami Chapel in
the church of San Gallo in
Florence.

Mariotto Albertinelli
(Florence 1474-1515)
Annunciation
Wood, 335x230 cm
Inv. no. 8643
From the Company of San
Zanobi in the Chapterhouse of
Santa Maria del Fiore in
Florence.

Mariotto Albertinelli
Madonna and Child with Saints
Wood, 231x205 cm
Inv. no. 8645
From the church of the nuns of
San Giuliano in Florence.

Girolamo del Pacchia
(Siena 1477-1535)
*Madonna and Child with the Young
St John*
Wood, diam. 89 cm
Inv. no. 3441
From the Giaccheri Bellondi
Collection.

Francesco di Cristofano called
Franciabigio
(Florence 1484-1524)
*Madonna and Child with St Joseph
and Young St John*
Wood, diam. 94 cm
Inv. no. 888
Provenance unknown.

Filippino Lippi
(Prato 1457 - Lucca 1504)
St John the Baptist
Wood, 136x56 cm
Inv. no. 8653
From the church of San Procolo
in Florence.

Filippino Lippi
St Mary Magdalen
Wood, 136x56 cm
Inv. no. 8651
From the church of San Procolo
in Florence.

Giovanni Antonio Sogliani
(Florence 1492-1544)
*Disputation over the Immaculate
Conception*
Wood, 347x230 cm
Inv. no. 3203
From the church of the nuns of
San Luca in Florence.

Francesco Botticini
(Florence 1446-1497)
St Augustine
Wood, 171x51 cm
Inv. no. 8625
Provenance unknown.

Pietro di Cristoforo Vannucci
called Perugino
(Città della Pieve c
1448-Fontignano 1523)
and Filippino Lippi
Deposition from the Cross
Wood, 334x225 cm
Inv. no. 8370
From the church of Santissima
Annunziata in Florence.

Francesco Botticini
St Monica
Wood, 171x51 cm
Inv. no. 8626
Provenance unknown.

Perugino
Assumption
Wood, 415x246 cm
Inv. no. 8366
From the church of
Vallombrosa near Florence.

Ridolfo del Ghirlandaio
(Ridolfo Bigordi)
(Florence 1483-1561)
Madonna and Child with Saints
Wood, 156x140 cm
Inv. no. 4652
From the Confraternity of the
Holy Sacrament at Sant'Andrea
a Mosciano near Florence.

Mariotto Albertinelli
The Holy Trinity
Wood, 232x132 cm
Inv. no 8660
From the convent of the nuns
of San Giuliano in Florence.

Bartolomeo di Giovanni
(Florence, documented from
1448 to 1511)
St Jerome in Penance
Wood, 147x146 cm
Inv. no. 8630
From the convent of Annalena
in Florence.

Fra Bartolomeo della Porta
*Madonna Enthroned with Angels
and Saints (Pitti Altarpiece)*
Wood, 351x267 cm
Inv. no. 8397

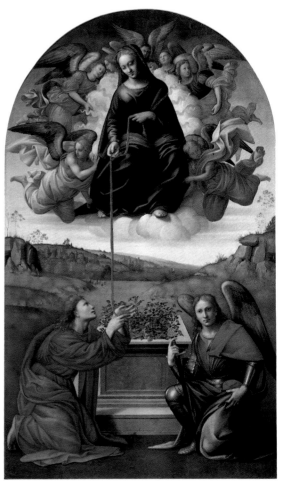

From the convent of Santa
Caterina in Florence.

Francesco Granacci
*Madonna della Cintola (Madonna
of the Girdle)*
Wood, 300x181 cm
Inv. no. 1596
From the church of San Pier
Maggiore in Florence.

Fra Bartolomeo della Porta
The Prophet Job
Wood, 169x108 cm
Inv. no. 1449
From the Billi Chapel in the
church of Santissima
Annunziata in Florence.

Francesco Granacci:
Madonna della Cintola

The Gallery of the *David*

When one enters the Gallery, the enormous central room, from the "Sala del Colosso," one's gaze cannot help but be caught by the *David*, standing solemnly, bathed in overhead light. But immediately afterwards one becomes aware of the huge blocks of marble at the sides, and it is only upon closer inspection that one realizes that they are sculptures, fashioned by a human hand. They are the *St Matthew*, which will be discussed below, and the four *Prigioni* (Prisoners or Slaves), carved by Michelangelo for the tomb of Pope Julius II. The artist was commissioned the work in 1505 and it became for him the "tragedy" of his life, as it has been defined: work on the tomb dragged on for forty years, amidst constant changes in the project, interruptions and fresh starts, the artist being torn between the need to work on new commissions and the demands of the pope's heirs. Eventually Michelangelo came up with a solution—

Michelangelo: David ▷

Daniele da Volterra: Bust of Michelangelo

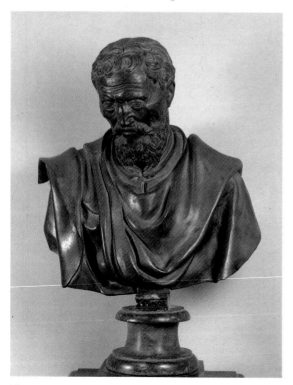

which can be seen today in the church of San Pietro in Vincoli in Rome—centred round the statue of Moses, which is but a pale reflection of the innovative and creative projects he had drawn up over the previous decades. These earlier projects also included the two *Slaves* at present in the Louvre in Paris, which date from the middle of the 1510s; while the four sculptures at the Accademia were probably carved in the early 1530s (although we have little documentation to prove it), before the artist settled in Rome for good in 1534.

The four *Prigioni* remained the property of the Buonarroti family in Florence until Leonardo Buonarroti, the artist's nephew, presented them as a gift to Grand Duke Cosimo I in 1564. The Grand Duke had them placed in Buontalenti's Grotto in the Boboli Gardens, where they remained until they were transferred to the Accademia in 1909. There is still much debate as to where they were to have been placed on Julius II's tomb; in any case, the huge figures were undoubtedly intended for the lower level of the monument where they were to function as telamones, that is as statues supporting the architectural construction above.

And in fact the figures give an almost physical impression of effort, especially the one that is known as *Atlas* (the last one to the left), who seems to want to throw off the upper part of the block of marble. These figures are struggling, with slow, tortured movements, towards freedom and release, like someone waking up to life and consciousness, a condition which corresponds precisely to their nature as unfinished statues. The observer, even though he is prepared thanks to his familiarity with the modern artistic concept of expressing messages also through personal and subjective forms, will be deeply surprised by the modernity of conception of these works: here, for the first time in art, the artist's task is not to provide a finished product for a specific customer, but to find an outlet for

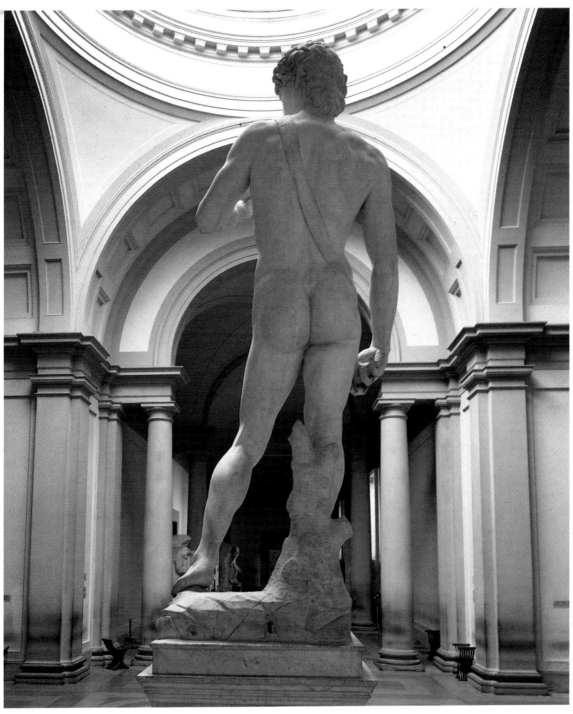

entirely personal ideas, feelings and thoughts. And this is why Michelangelo's famous unfinished style—of which these statues are the most obvious example—is totally sufficient, as long as the artist has managed to achieve a level of expression that satisfies his own needs. Of course we must also take into consideration the practical circumstances, which are particularly important in the case of these statues, intended for a tomb that Michelangelo was never able to complete in the way he would have wanted. But we know from our sources that even the artist's contemporaries had realized the novelty of Michelangelo's idea and acknowledged its value. Vasari, in 1568, wrote about the Madonna in the Medici Chapels in San Lorenzo: "Even though it is not finished in all its parts, one can distinguish in the fact that it has remained un-

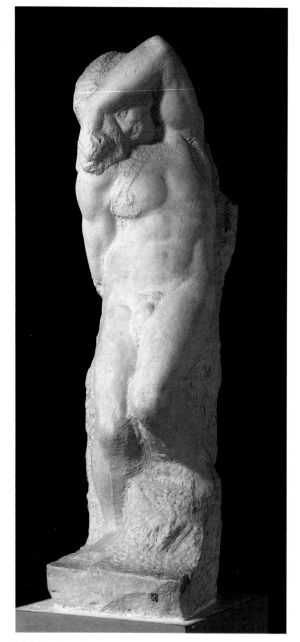

Michelangelo: The Young Slave

line that it forms together with the left side of the body and the leg, are characteristic of Michelangelo. Also characteristic is the torsion of the body, when seen frontally, while the legs still show a faint idea of the inanimatedness of matter, which the artist is called upon to breathe life into. The right arm behind the back suggests the idea of bondage.

The figure opposite, the first to the left, is still more constrained by the block of marble. He is of an almost overwhelming power and is called the *Awakening Slave*. His awakening takes place in struggle, in a spasmodic fight against obscure powers, probably the forces of Original Sin as understood by Roman Catholic doctrine, but which are here seen as a condemnation that is almost without reprieve since it appears to be an integral part of the human condition, with no hope of redemption or divine Grace. Placed on the lower level of the monumental tomb, the *Prigioni* were intended to symbolize mankind before the coming of Christ, still subject to earthly mortality; mankind had then been freed from death by the Christian faith, symbolized by the figures in the upper zones. In the *Awakening Slave* the anatomy of the torso is shown in the full tension of effort, in the powerful strength of the huge muscles.

Further on to the right, after the *St Matthew*, is the figure known as the *Bearded Slave* who appears to be almost crushed by his own weight, with his legs bending. His muscle structure and his anatomy are those of an older man. The feeling the figure puts across is one of melancholy, which makes him reminiscent of the sculpture of *Twilight* in the Medici Chapel. The expression on his face is thoughtful and suffering, as though to suggest that he is bound by a form of impotence, like someone who is unable to take upon himself the determination of his own destiny. These giants are Titans who cannot exalt their own strength, since it cannot help them shake off the bonds that constrain them, for they are spiritual not physical chains; the bondage is spiritual because the marble is itself a reflection of dark inner needs, against which all struggle is powerless.

finished. . . in the imperfection of the unfinished stone the perfection of the work." In 1671, while discussing the *Prigioni*, Bocchi wrote: "And these statues are that much more marvellous in this state, than if they were finished, and they are more admired, studied and contemplated by the most skilled artists than if they had received Buonarroti's last touch."

The first figure to the right is commonly called the *Young Slave*. The movement of his raised left arm, the elongated and sinuous

Everything we have said so far about the *Prigioni* can be summed up and completed by an examination of the last one, called *Atlas*, to the left opposite the *Bearded Slave*. His head is barely roughed out and is actually quite difficult to distinguish. The strength and power of the figure is expressed primarily by the carving of the left side of the body; but it is the righthand side that shows how the figure is still imprisoned in the block of marble. His legs are astride the marble, as though about to spring up in order to gain independence.

The head, on the other hand, is still almost entirely constrained, while the arms appear to be trying to shake off the inanimate matter that weighs as heavily as a condemnation. Here the struggle becomes explicit and the arms clearly show the effort. This is the most obvious description of the striving to go beyond one's own limitations, characteristic of Michelangelo's artistic expression. The artist was profoundly influenced by Humanist Platonic philosophy, but he was never able to separate it from his own personal religious ideals. According to Plato, man reaches superior knowledge, the philosopher's knowledge, by degrees, casting off false opinions and ultimately drawing solely on the truth of Ideas. To reconcile this pagan and gnostic philosophical process with the Christian theory of salvation was a near impossible task, and Michelangelo felt it as the crucial drama of his existence.

Between the two *Prigioni* on the right there is another unfinished statue, the *St Matthew* that Michelangelo sculpted between 1505 and 1506. In 1503 the artist had been commissioned twelve statues of the Apostles, which were to have been placed in the chapels in the chancel of Florence Cathedral (or perhaps against the pilasters); he was to have sculpted one a year for twelve years. The only statue Michelangelo ever worked on, however, was this *St Matthew*, which remained at the Opera del Duomo until 1834 when it was transferred to the Accademia. The block of marble is flatter than those used for the *Prigioni* and the figure was only intended to be seen frontally; the idea is more of a relief than of a free-

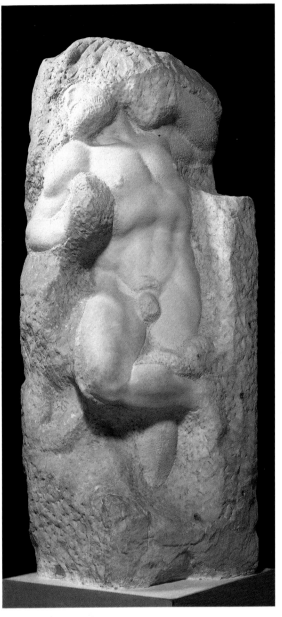

Michelangelo: The Awakening Slave

standing statue, possibly also as a reference to the typical technique used by Donatello, who had carved a similar series of figures for the bell tower of the same Cathedral (now in the Cathedral Museum). In this figure of the Apostle Michelangelo's technique is clearly visible: a dense network of parallel strokes, similar to his ink drawings. The lefthand side, on the other hand, shows the marks of the chisel that has chipped off heavy fragments of marble, almost like a spoon scooping up food.

In the *St Matthew*, too, what is most striking is the dramatic tension of the figure, which

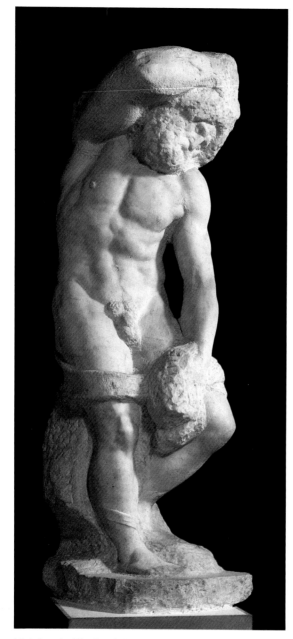

Michelangelo: The Bearded Slave

pentine form" of German fifteenth-century artists (and we know that he studied Schongauer's engravings with great interest), transforming it into Cinquecento monumentality. But unlike the works of second generation Mannerists, here torment is not simply a formal convention, but the outward expression of an inner existential condition: it is not contrived, but deeply and desperately felt. Had the artist sculpted all twelve Apostles, the Cathedral of Florence would have been filled with a crowd of anguished figures, each locked in his own incommunicable suffering.

Beyond the door to the right after the *Bearded Slave* is the *Palestrina Pietà*. The huge marble group was in a chapel belonging to the Barberini family in Palestrina (a small town east of Rome that the Barberini had taken over from the Colonna family in 1630), when it was bought by the Italian State in 1939. There is no documentation concerning this sculpture, which is quite unusual for a work by Michelangelo, since all his others are generally well documented. The first reference to Michelangelo in connection with the group is in a "History of Palestrina" written in 1736.

The attribution to Michelangelo was generally accepted during the first half of this century, for it was seen as another example of his grandiose style, as though he was reproducing in three dimensions and in marble the titanic figures he had frescoed in the *Last Judgment* on the end wall of the Sistine Chapel between 1536 and autumn 1541. It is mostly recent critics and scholars who have expressed doubts on the attribution to Michelangelo of the *Palestrina Pietà*, culminating in the positions taken by De Tolnay or Wittkower who do not think that Michelangelo is the author at all. This may be a good moment to try and approach the problem again, with a more balanced attitude, bearing in mind the more original observations expressed.

The first conclusion that we propose is that it is unlikely that the group is entirely the work of Michelangelo, and on this matter De Tolnay's assertions are quite valid. He points out that the work is only intended to be seen frontally, which stands in striking

does not try to impose upon the spectator the idea of a superior domination of passions, but is not afraid of communicating all its internal torment. The left leg breaks out from the marble and twists, thus making the torso rotate in the other direction; the head leans sideways and backwards. These are already the forms and methods of the Mannerist sculpture of Giambologna among others, but applied to relief work instead of to a free-standing statue. Michelangelo seems to be going back to the "ser-

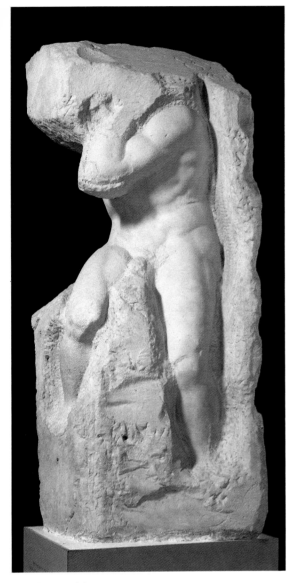

Michelangelo: Atlas

enormous, and the rest of the body. Even the carving technique appears to be a not terribly successful attempt at imitation of Michelangelo's style, rather than fully conscious application of it. The conclusion that seems most probable, and which must of course take into consideration the partial but undeniable connection with some of the artist's methods, is that this is a composite operation, that cannot have been conceived entirely outside Michelangelo's circle, but that cannot have been totally carried out under the artist's direct supervision either. Therefore, it is probably a conscious imitation of the poetic world of Michelangelo, but seen from the outside; it does not succeed because the great artist's thoughts and ideas are basically inimitable and "untranslatable." And yet an attempt like this could not really have taken place except in connection with Michelangelo's entourage, or maybe even under the master's supervision, offering suggestions, advice, and perhaps even the occasional intervention (in particular, on the torso of Christ). In any case, the sculpture is highly problematic and therefore extremely interesting, not as a documentation of Michelangelo's personal activity but as the work of a restricted circle of followers, attempting to grasp his complex ideas.

At the centre of the Tribune there is a work that poses no fewer problems: it is the *David*, the statue-cum-fetish, the international symbol of the art of sculpture, the masterpiece which shares with Leonardo's *Mona Lisa* alone the questionable privilege of being the best known work of art for all the civilizations of the Western world (. . . and not only in the West). I have always thought and still do that it is a particularly difficult work to understand and appreciate, one that doesn't immediately disclose its message without reserves. On the contrary, it requires a highly educated approach, made possible that is through the study and knowledge of history of art and, broadly speaking, of the culture of the time. In order to break away from the current fetishistic attitude towards the *David*, one must not move away from it but, on the contrary, come closer; study it in detail, observe it

contrast with the artist's mature and late period. It is also extremely unlikely that Michelangelo would have accepted to work on a block of marble that came from a classical building (as can be seen from the fragments of architectural decorations at the back), and which from the very beginning must have been obviously too flat and shallow to allow the carving of the back of the figures, which therefore are broken off abruptly. The relationship between the torso with its powerful muscular structure and the legs, totally insufficient to sustain the body's weight, is disconcerting to say the least; just as the striking lack of proportions between Christ's right arm, thick, heavy,

impartially, learn as much as possible about the circumstances surrounding its commission, the condition of the marble before Michelangelo began work, how Michelangelo approached the problem. Only like this will we be able to see the *David* again, to retrieve its real meaning and quality; for it must be said that many people have as it were rebelled against the *David*, an attitude that is psychologically understandable but definitely not acceptable.

I shall provide here just some of the information necessary in my opinion to begin to "come closer" to the *David*. Work was begun on the piece of marble by Agostino di Duccio, a Florentine sculptor, between 1462 and 1463; but Agostino soon abandoned it, since he thought he would never get anywhere with such a tall and thin piece. In 1476 another Florentine sculptor, Antonio Rossellino, did not have much more success. So Michelangelo was confronted first of all with a difficult theoretical problem, and the *David* reflects this extraordinary work of research. Once he had cleared the problem in his mind, Michelangelo worked on the sculpture for two years, 1502 and 1503; on 25 January 1504 the statue was "almost finished." An especially formed committee decided that it should be placed in front of the Palazzo Vecchio, seen as the embodiment of civic virtues; gradually the *David* became a symbol of these virtues and, over the centuries, of the free and republican city, or at least of independence. The young man who slays with his sling a powerful enemy became and remained the symbol of the strength of a people struggling for its independence.

Michelangelo introduced several iconographical innovations. David is portrayed as a young man, not as a boy, and he is completely naked, in a sort of exaltation of the human anatomy that sums up and defines for the future every earlier interest and scientific research on the body. In the statue there is no precise reference to the action, which appears to be quite distant (the stone is in his right hand, while the sling, barely recognizable, is in his left, behind his back). Therefore the psychological element centres round the intention, not the action; physical

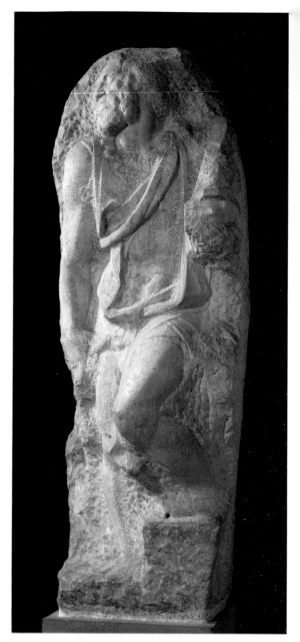

Michelangelo: St Matthew

strength is not portrayed explicitly, but contained within the body, which thus becomes an extraordinary concentration of power. The figure's expression reveals a sense of challenge and of confidence in his own abilities, the self-confidence of those who know they are in the right. His head and his right hand are disproportionately large, which emphasizes the two nerve centres of thought and action, but also introduces a bewildering element, a subtle anxiety, for the classical canon of Renaissance and Humanist proportions is consciously broken.

The contrast between the righthand side, enclosed and finished, and the lefthand, open and broken, gives a further element of movement: a barely perceptible tremor runs through this powerfully explicit figure. To conclude, the statue is far more complex than it appears at first sight. So, one should try to forget the crowds that usually surround it, and set up with it, if not a dialogue (which is always impossible with Michelangelo's statues, since they are not intended for a worldly public), at least a moment of verification and of testing; this will allow one to verify that the fame of the *David* (regardless of the attraction it exerts which is a phenomenon more closely connected to mass communication studies) is undoubtedly not undeserved. It is one of those creations which, in the history of our civilization, offer us the culture of an age at its highest level; it is for this reason, and not because they are "timeless," that their language becomes universal, and that, after 480 years, it continues to speak to us with words that are still deeply part of our consciences.

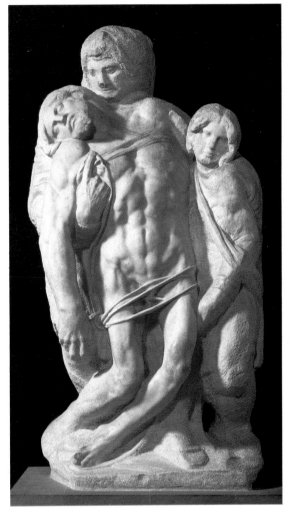

Attributed to Michelangelo: The Palestrina Pietà

▷
Michelangelo: David

▷▷
Michelangelo: David, detail

To the left:
Michelangelo Buonarroti
(Caprese 1475-Rome 1564)
The Awakening Slave
Marble, height 267 cm
Inv. no. 1078
From Buontalenti's Grotto in
the Boboli Gardens, Florence.

Michelangelo Buonarroti
Atlas
Marble, height 277 cm
Inv. no. 1079
From Buontalenti's Grotto in
the Boboli Gardens, Florence.

To the right:
Michelangelo Buonarroti
The Young Slave
Marble, height 256 cm
Inv. no. 1080
From Buontalenti's Grotto in
the Boboli Gardens, Florence.

Michelangelo Buonarroti
St Matthew
Marble, height 271 cm
Inv. no. 1077
From the Academy of Fine Arts
in Florence.

Michelangelo Buonarroti
The Bearded Slave

Marble, height 263 cm
Inv. no. 1081
From Buontalenti's Grotto in
the Boboli Gardens, Florence.

Attributed to Michelangelo
Buonarroti
The Palestrina Pietà
Marble, height 253 cm
Inv. no. 1319
From the Barberini family
chapel in Palestrina.

Michelangelo Buonarroti
David
Marble, height 410 cm
Inv. no. 1076
From Palazzo Vecchio in
Florence.

Daniele da Volterra
(Volterra c 1509 – Rome 1566)
Bust of Michelangelo
Bronze
Inv. no. 1083

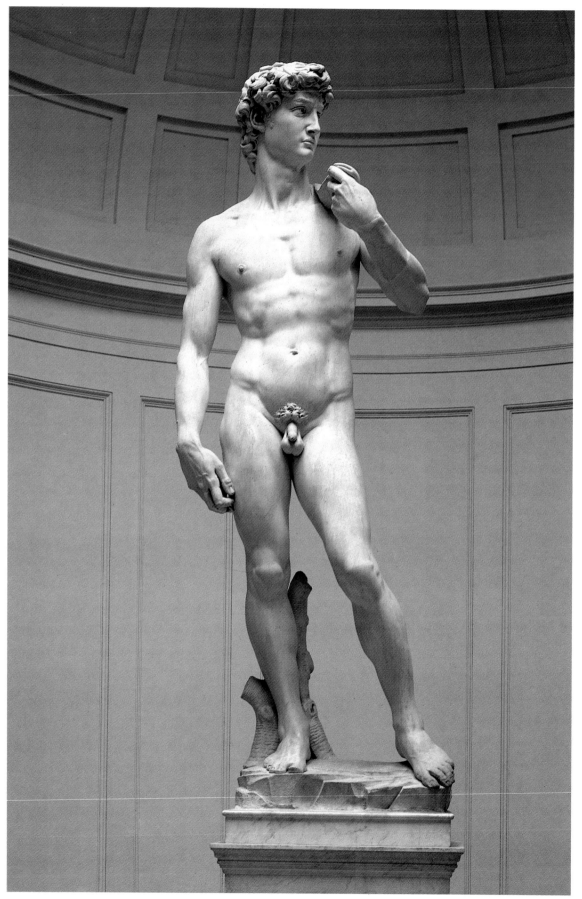

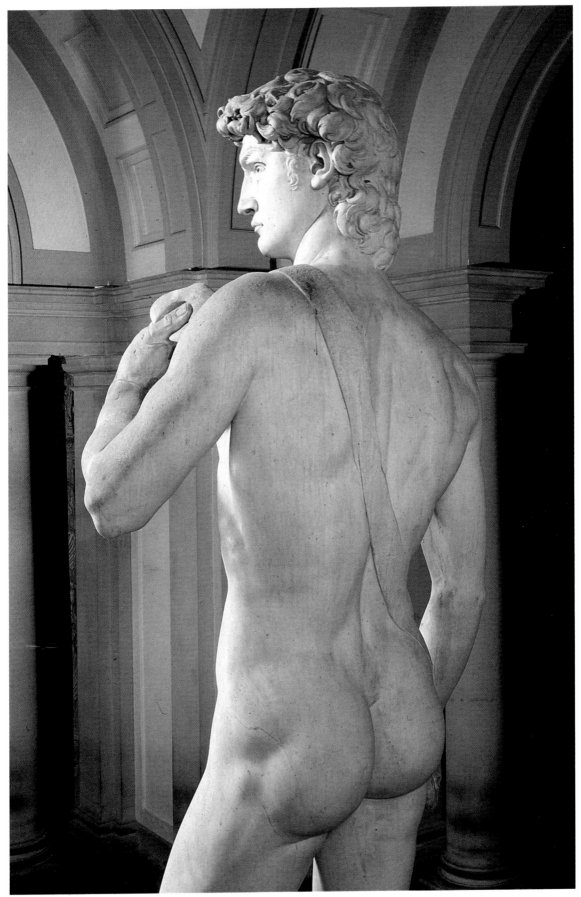

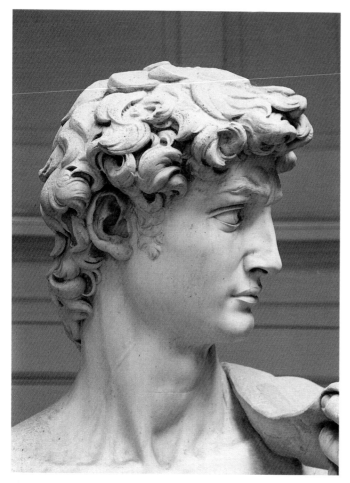

Michelangelo: David, details

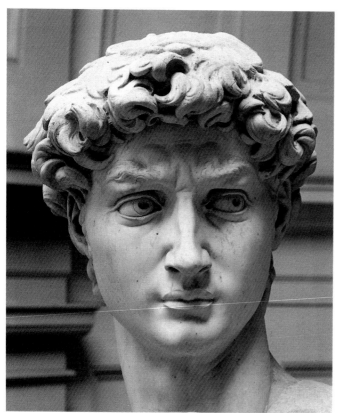

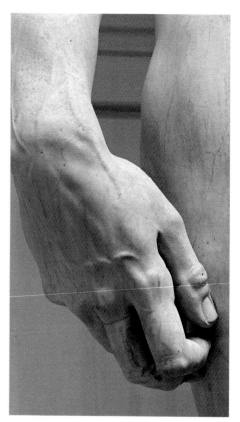

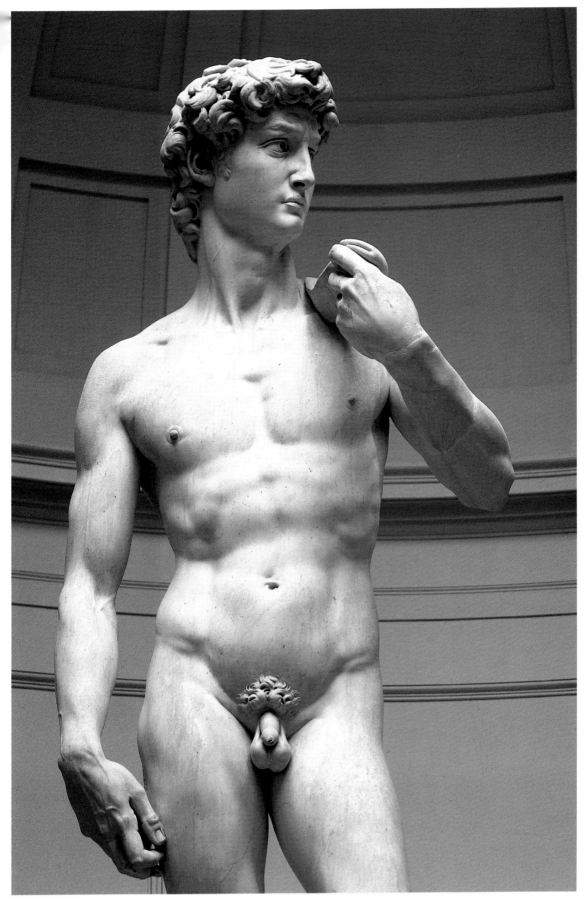

"Sale Fiorentine"

The three rooms called "Sale Fiorentine" house paintings from the fifteenth century, examples of the most typical Florentine production of the time. The entrance to these rooms is on the right of the Gallery, just before the *Palestrina Pietà*. With a few exceptions, the paintings exhibited here are of minor importance, but, as we have said before, the Accademia must not be seen as a gallery of masterpieces, but rather as a first rate historical documentation of the development of Florentine art, seen through the original commissions, secularizations, appropriations to public collections, and so on. From this point of view, the "Sale Fiorentine" offer an interesting collection as well.

In the first room there are works by artists such as Mariotto di Cristofano, Andrea di Giusto, Domenico di Michelino, Cosimo Rosselli. The first three are indicative of how artists of lesser talent reacted to the new Renaissance art of Masaccio and Fra Angelico; Rosselli instead ran an extremely popular workshop in the late fifteenth century and his work was much appreciated by his contemporaries. On the righthand wall there is Andrea di Giusto's *Madonna of the Girdle between Saints Catherine and Francis* (this subject shows the Virgin leaving her belt to St Thomas, as tangible evidence of her presence). On the little side pilasters there are other saints; above, under the pediment, there are two prophets; the predella shows, in the middle, the *Death of the Virgin*, to the left, the *Martyrdom of St Catherine*, and to the right, the *Stigmatization of St Francis*. The painting is signed and dated, at the centre of the plinth: *Andreas de Florentia MCCCCXXXVII*.

It is interesting to notice how old-fashioned elements survive alongside the novelties. For example, the panel still shows echoes of the traditional division of paintings into triptychs in the three arches in the upper part of the composition; but the arches are not completed by columns in the lower part. In other words, there is an attempt to blend the Gothic concept of divided space with Renaissance unity of space. In the same way, the background is a solid gold backdrop, without any attempt at depiction of space; but the Madonna placed at the centre, and the plinth of the throne she is seated on are painted according to the rules of Renaissance perspective, with a single vanishing point. Andrea di Giusto, who died in 1450, was one of the first to realize the innovations present in the work of Masaccio, whose work he was constantly copying.

Andrea also turned his attention towards Fra Angelico, a painter whose role as a protagonist of the Renaissance is gradually becoming clearer, especially since his frescoes in San Marco have been restored. But Andrea's interest in Angelico was probably not so exclusive as that of the unidentified artist who painted the lovely *Madonna and Child, Two Angels and a Man of Sorrows* with a *Memento Mori* (a warning of the inevitability of death) painted on the plinth, illustrated by the words: *Respice frater qualis eris: fui sicut tu es* (Observe, brother, how you will become: I once was as you are now), at the centre of the righthand wall, above the *Adimari Cassone* (which we shall discuss below). The painting in fact is extremely similar to the work of Angelico in the mid–1430s, and even shows the same interest in the art of Paolo Uccello (in the sharp profiles and well-defined lines). The painting deserves to be examined as a culturally important work, even though its precise origins still need to be studied.

Underneath it is the famous painting known as the *Adimari Cassone*. These *cassoni*, or wooden chests, were used in fifteenth-century Florence as cupboards for clothes and linen. Very frequently they were built and decorated on the occasion of a wedding, and were part of the bride's trousseau.

For a long time this chest was thought to have been made for the wedding of Boccaccio Adimari and Lisa Ricasoli; but this is not possible, since the wedding took place in 1420 and the painting must be dated, on stylistic grounds, at about twenty years later. In any case, thanks to Luciano Bellosi, we know at least the name of the artist, Giovanni di Ser Giovanni, known as Scheggia, who was Masaccio's stepbrother. The extremely well-known painting is undoubtedly attractive for the description it offers of Florentine daily life, clothing, and the city's architecture. But a closer inspection will inevitably reveal a mediocre artistic talent.

Further along the righthand wall there is a *Nativity* from the Medici villa of Castello, which gives its name to the unidentified artist, Master of the Castello Nativity. The artist is a painter of great talent, whose style reflects primarily the work of Filippo Lippi, but also shows acquaintance with Fra Angelico's sense of colour and the drawing technique of Alessio Baldovinetti. It dates most probably from just after 1450.

Still further on is an altarpiece showing the *Madonna and Child with the Young St John, St James and St Peter*, from the convent of Santa Maria Maddalena dei Pazzi in Florence. It is a late work by Cosimo Rosselli (Florence 1439-1507), probably painted around 1500; the highly elaborate throne and the unconvincing architectural construction reveal the influence of a far greater artist, Filippino Lippi. Rosselli was in fact a rather mediocre painter ("his works were reasonable," writes Vasari), even though he was awarded very grand commissions, such as three large frescoes in the Sistine Chapel in the Vatican. In any case, it was in his workshop that such a great and fascinating painter as Piero di Cosimo was trained.

Among the other works in this room, let us take a look at the ones placed in the middle of the room. On one trestle, placed back to back, are Domenico di Michelino's *Madonna and Child with Angels* from the convent of San Girolamo sulla Costa and the *Tobias with the Three Archangels* (with below it a crucifix, rather like the door of a ciborium) originally in the convent of Santa

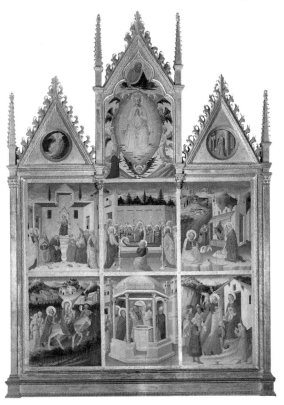

Mariotto di Cristofano: Stories from the Life of Christ and the Virgin

Andrea di Giusto: Madonna of the Girdle

Felicita. Born in 1417, Domenico di Michelino lived until 1491 without, however, producing any works of great quality. He began his training in the circle of Fra Angelico and he may even have worked together with the Dominican friar on some projects. Domenico di Michelino painted the extremely famous fresco in Florence Cathe-

Benozzo Gozzoli: Saints Bartholomew, John the Baptist and James

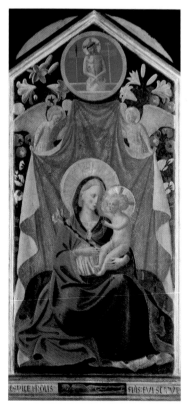

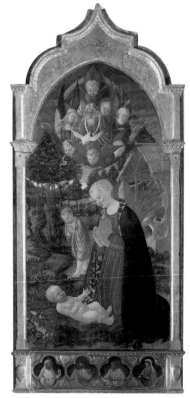

◁
Follower of Fra Angelico: Madonna and Child

Master of the Castello Nativity: Nativity

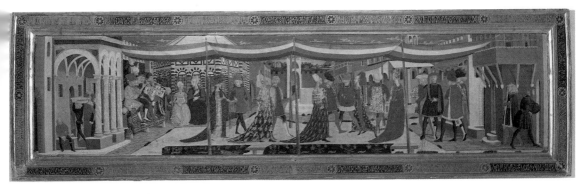

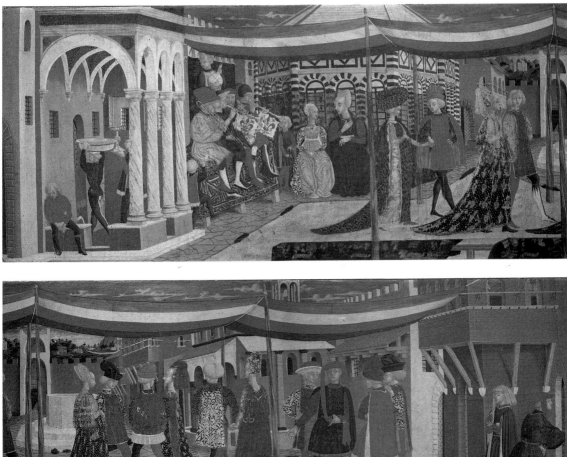

Master of the Adimari Cassone: "The Adimari Cassone"

dral, showing Dante explaining his *Divine Comedy*, which we all remember well. In this painting of Tobias, the artist is revealed as rather mediocre, particularly in the figures with their heavy and expressionless faces. On the other trestle there are two works:

the *Resurrection of Christ* and the *Wedding of St Catherine with Saints Dorothea, Agnes, Mary Magdalen and Elizabeth*, from the Hospital of Santa Maria Nuova. They were painted by Mariotto di Cristofano (San Giovanni Valdarno 1393 – Florence 1457), who was

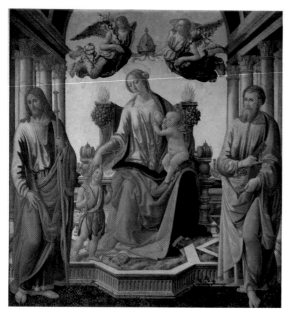

Cosimo Rosselli: Madonna and Child with Saints

Cosimo Rosselli: Madonna and Child Crowned by Two Angels

Masaccio's brother-in-law since he had married one of his stepsisters; it may well have been Mariotto who first brought the young genius to Florence. The two paintings date from 1445-1447 and in fact the composition of the *Wedding* shows obvious familiarity with the construction principles of a Renaissance altarpiece, of which there were then only a few examples, the work of Angelico, Lippi, or Domenico Veneziano. Mariotto's work is undoubtedly rather limited and schematic; his understanding and use of perspective is mediocre. But this unsophisticated version of more successful examples is interesting.

The small corner room, adjacent to the one described above, contains some extremely important works. Particularly noteworthy is a *Madonna* by Sandro Botticelli (1445-1510), painted in the early 1470s and recently restored. The meditative and slightly stern expressions still show the youthful freshness of Botticelli's early work, as do the fairly harsh colours and the gestures which, although naturalistic, are rather stilted. It is in any case a fascinating work of excellent quality, that could only have been painted by a truly major artist.

The large partly ruined painting on the end wall, showing the *Holy Trinity with Saints Benedict and John Gualberto*, once stood on the high altar of the church of Santa Trinita in Florence; we know from documents that it was painted in 1471. It is the work of Alessio Baldovinetti (Florence 1425-1499) who trained in the workshop of Fra Angelico and later painted delicate works, characterized by an instinctive understanding of the values of line and drawing as is shown by his remarkably elegant paintings. Unfortunately many of his works have come down to us in poor condition: from this altarpiece, ruined by a bad restoration a long time ago, to the fresco in the cloister of Santissima Annunziata, to the banner in the Museum of San Marco. This painting had an extraordinary composition and, in fact, all the artist's iconographical solutions are interesting and original.

To the right of Baldovinetti's large altarpiece there is a small canvas which is one of the most puzzling paintings in the Ac-

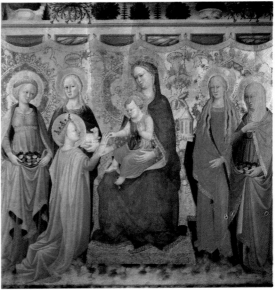

△
Workshop of Domenico di Michelino: Madonna and Child with Saints

Mariotto di Cristofano: Resurrection

△
Domenico di Michelino: Tobias with the Three Archangels

Mariotto di Cristofano: The Wedding of St Catherine

cademia. The subjects is a *Thebaid*, that is a desert peopled with hermits, which is the subject of several other paintings; the most famous of them is the one in the Uffizi, traditionally attributed to Starnina, but more likely to have been painted by Fra Angelico around the mid–1420s. The painting in the Accademia probably dates from the 1440s; it comes from the convent of the Spirito Santo on Costa San Giorgio and presents several problems which have been the object of many debates. It has in fact been suggested that a whole group of works, in the past attributed by scholars to artists working in the style of Paolo Uccello, to the extent at times of forming fictitious groups of works ascribed to the "Master of Karlsruhe" or the "Master of Prato," should actually be considered the work of Uccello himself. This is certainly the theory I prefer, for there seems no reason to differentiate between paintings like this one, with their composite and artificial perspective, and the research of Uccello. The mixture of fantasy

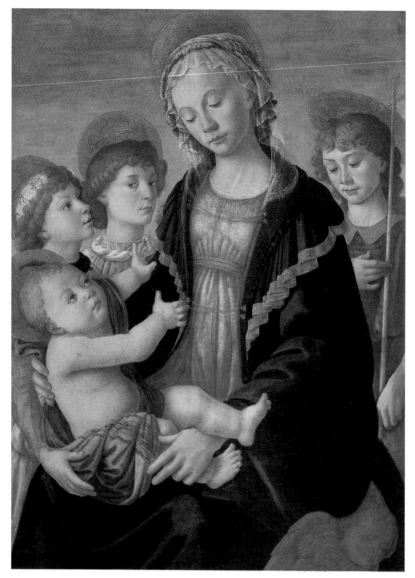

Sandro Botticelli: Madonna and Child with the Young St John and Two Angels

Paolo Uccello: "Thebaid"

Alessio Baldovinetti: The
Holy Trinity with Saints
Benedict and John Gualbert(

▷
Perugino: Visitation

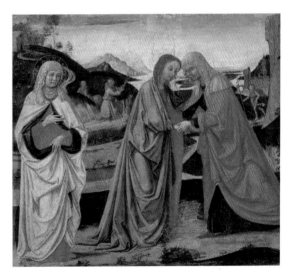

and rationality in this painting is perfectly in line with the characteristic style of Paolo Uccello (1397-1475), a painter who is one of the fathers of Renaissance art.

Another small painting, next to the window, is also particularly interesting. It shows the *Visitation*, the meeting of the Virgin and St Elizabeth, and was originally in the convent of the nuns of the Crocetta in Florence. It is now generally thought to be the work of Pietro Perugino (Pietro Vannucci, Città della Pieve c 1448 – Fontignano 1523) during his early period in Florence, around 1470, when he was working in Verrocchio's workshop. As such, the painting is rare and culturally very interesting. It shows that the young artist had already developed that mental clarity and that ability to translate complex problems in simple terms that characterizes his best works; the same talents that will be taken up by the young Raphael and developed to an even greater degree (whether or not Raphael was his apprentice and nowadays it is considered unlikely).

In the following room, the last of this group, on an easel in front of the curtain that closes off a doorway leading to the "Sala del Colosso," There is a small painting

called the "*Madonna del Mare*" (Madonna of the Sea) and usually attributed to the young Botticelli. Originally in the convent of Santa Felicita, it is considered a youthful work, painted around 1470. But if we compare it to the Madonna in the previous room, which is quite typical of Botticelli's early work, we can notice the difference: the *Madonna del Mare* is gentler, the modelling is softer, the drawing less evident. There is no doubt that the small painting is of exceptional quality, but it now seems more likely that it is the work of the great Filippino

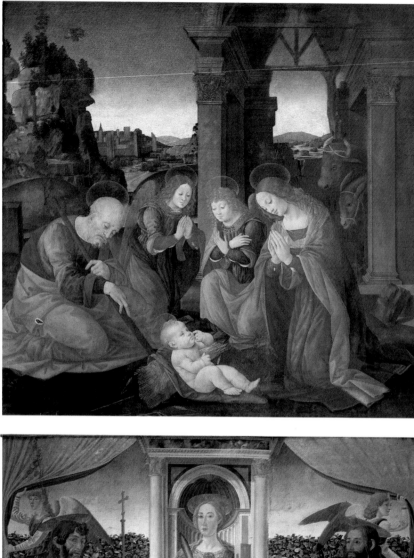

Lorenzo di Credi: The Virgin,
St Joseph and Two Angels in
Adoration of the Christ Child

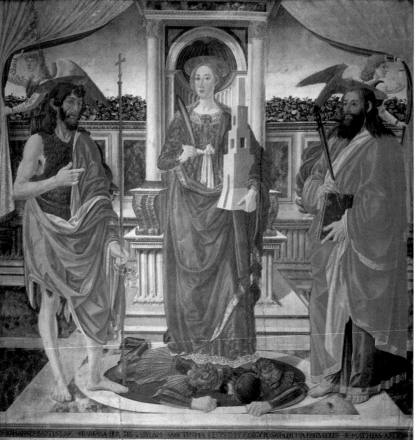

Cosimo Rosselli: Saints John
the Baptist, Barbara and
Matthew

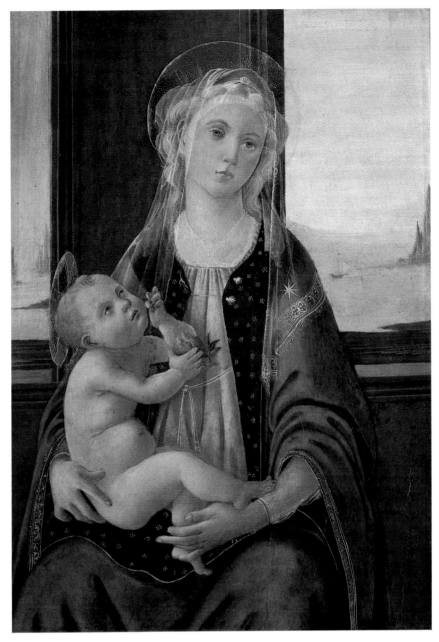

Attributed to Sandro
Botticelli: "Madonna del
Mare"

Lippi, who began his career very much under Botticelli's influence—so much so that in the past his early paintings were attributed to an unidentified artist called simply "Sandro's friend."

There are other important paintings in this room: *St Barbara between St John the Baptist and St Matthew*, for example, from the convent of Santissima Annunziata, is a youthful work by Cosimo Rosselli, to be dated around 1470. It is interesting to notice the differences between this early work and the later altarpiece in the first room of the "Sale Fiorentine." This early work is much more interesting and of higher quality: the naive style, the rigid and almost carved drawing (which, however, succeeds in giving relief to the figures), and the pale colours, indicate familiarity with the works being produced in Verrocchio's workshop.

The room contains other paintings that document Florentine culture in the very last years of the Quattrocento; among them, particularly worthy of note is the *Resurrection of Christ* on the end wall. It is the work of a painter who is still basically little known, Raffaello de' Carli, called Raffaellino del Garbo (Via del Garbo was the

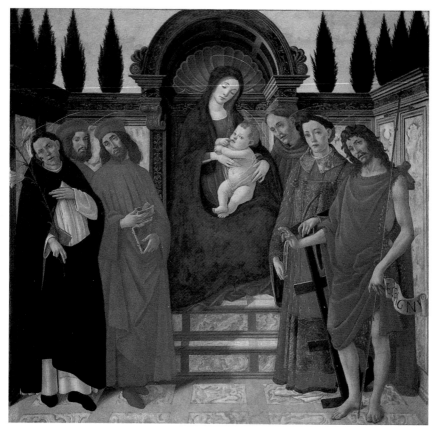

Sandro Botticelli and assistants: Madonna and Child with Saints

▷
Raffaellino del Garbo: Resurrection

▷▷
Follower of Cosimo Rosselli: Coronation of the Virgin

name of the street where he had his workshop). He was born around 1470 and died around 1524. Critics today have more or less the same opinion as was expressed by Vasari, that is that he began his career with great promise but never truly succeeded. He was an apprentice of Filippino Lippi and was in turn Bronzino's first teacher; fundamentally, he was unable to adapt to the innovations of Florentine Mannerism, and continued to paint in an old-fashioned style well into the sixteenth century. The *Resurrection* at the Accademia comes from the Cappella del Paradiso under the church of San Bartolomeo a Monte Oliveto, that belonged to the Capponi family. The lively and inventive composition clearly shows the influence of Filippino Lippi, his teacher, but the figures, when examined individually, possess none of the bizarre elements of Filippino's. The painting was much admired in its time (Vasari writes that it was held as "a piece of rare quality") and is certainly Raffaellino's masterpiece.

Also in this room are paintings by Biagio d'Antonio, Jacopo del Sellaio, Sebastiano Mainardi (Ghirlandaio's brother-in-law), and an altarpiece by the school of Botticelli from the Medici castle of Trebbio, offering a panorama of the figurative culture of the time in Florence.

Room 1

Mariotto di Cristofano
(San Giovanni Valdarno
1393-Florence 1457)
*Stories from the Life of Christ and
the Virgin*
Wood, 225x175 cm
Inv. no. 8508
From the church of
Sant'Andrea a Doccia near
Florence.

Andrea di Giusto
(Florence, documented from
1424-died in 1450)
*Madonna of the Girdle between
Saints Catherine and Francis*
Predella: *Martyrdom of St
Catherine, Death of the Virgin* and
Stigmatization of St Francis
Wood, 185x220 cm
Inv. no. 3236
From the church of Santa
Margherita in Cortona; later in
the Bardelli Tommasi
Collection.

Domenico di Michelino
(Florence 1417-1491)
*St Bernardino of Siena and Two
Angels*
Wood, 175x80 cm
Inv. no. 3452
From the monastry of San
Bartolomeo at Monteoliveto
near Florence.

Benozzo Gozzoli
(Florence 1420/22-Pistoia
1497)
*Saints Bartholomew, John the
Baptist and James*
Wood, 171x22.5 cm
Inv. no. 8620
From the Compagnia di
Purificazione in the convent of
San Marco in Florence.

Master of the Adimari Cassone
(Giovanni di Ser Giovanni
Guidi called Scheggia)
(San Giovanni Valdarno
1407-Florence 1486)
*Cassone, or chest, showing a wedding
("The Adimari Cassone")*
Wood, 63x280 cm
Inv. no. 8457
Purchased by the Tuscan
Government.

Follower of Fra Angelico
(Florence, 1435/40)
*Madonna and Child, Two Angels
and Man of Sorrows*
Wood, 101x49 cm
Inv. no. 6004
Provenance unknown.

Follower of Pier Francesco
Fiorentino
(Florence, mid-15th century)
Madonna in Adoration of the Child
Wood, 48x32 cm
Inv. no. 3158
From the Hospital of Santa
Maria Nuova in Florence.

Andrea di Giusto
*Madonna and Child with Two
Angels*
Wood, 117x57 cm
Inv. no. 3160
From the Hospital of Santa
Maria Nuova in Florence.

Domenico di Michelino
*Saints Michael, Lawrence and
Leonard*
Wood, 171x22.5 cm
Inv. no. 8621
From the Compagnia di
Purificazione in the monastery
of San Marco in Florence.

Master of the Castello Nativity
(Florence, mid-15th century)
Nativity (Birth of Christ)

Wood, 213x98 cm (including
the predella)
Inv. no. Dep. 171
From the Medici villa of
Castello, near Florence.

Cosimo Rosselli
(Florence 1439-1507)
*Madonna and Child with the Young
St John between Saints James and
Peter*
Wood, 230x190 cm
Inv. no. 1562
From the convent of Santa
Maria Maddalena de' Pazzi in
Florence.

Workshop of Filippo and
Filippino Lippi
(Florence, second half of the
15th century)
Annunciation
Wood, 180x175 cm
Inv. no. 4632
From the church of San Firenze
in Florence.

Domenico di Michelino
The Holy Trinity
Wood, 133x71 cm
Inv. no. 8636
From the church of San
Pancrazio in Florence.

Cosimo Rosselli
*Madonna and Child Crowned by
Two Angels*
Wood, 189x127 cm
Inv. no. 3205

From the Hospital of Santa
Maria Nuova in Florence.

Workshop of Domenico di
Michelino
(Florence, second half of the
15th century)
Madonna and Child with Saints
Wood, 180x189 cm
Inv. no. 3450
From the convent of the
Franciscan nuns at San
Girolamo sulla Costa, Florence.

Domenico di Michelino
Tobias with the Three Archangels
Wood, 170x171 cm
Inv. no. 8624
From the church of Santa
Felicita in Florence.

Giovan Francesco da Rimini
(documented from 1441 to
1470)
St Vincent Ferrer
Predella: *Three episodes from the
life of the saint*
Wood, 145x70 cm
Inv. no. 3461
From the convent of the nuns
of San Domenico del Maglio in
Florence.

Mariotto di Cristofano
Resurrection
Wood, 160x155 cm
Inv. no. 3164
From the Hospital of Santa
Maria Nuova in Florence.

41

Biagio d'Antonio: Annunciation and God the Father

Mariotto di Cristofano
The Wedding of St Catherine
Wood, 160x152 cm
Inv. no. 3162
From the Hospital of Santa
Maria Nuova in Florence.

Room 2

Workshop of Lorenzo di Credi
(Florence, early 16th century)
*Madonna and Child with the Young
St John and a Martyred Saint*
Wood, diam. 68.5 cm
Inv. no. 9202
From the warehouses of the
Technical Department,
Florence.

Sandro Botticelli (Alessandro
Filipepi)
(Florence 1455-1510)
*Madonna and Child with the Young
St John and Two Angels*
Wood, 85x64 cm
Inv. no. 3166
From the Hospital of Santa
Maria Nuova in Florence.

Paolo Uccello (Paolo di Dono)
(Florence 1397-1475)
*Scenes of monastic legends
("Thebaid")*
Canvas, 81x111 cm
Inv. no. 5381
From the convent of Spirito
Santo sulla Costa in Florence.

Alessio Baldovinetti
(Florence 1425-1499)
*The Holy Trinity with Saints
Benedict and John Gualberto*
Wood, 238x284 cm
Inv. no. 8637
From the high altar of the
church of Santa Trinita in
Florence.

Florentine painter of the late
15th century
Annunciation
Wood, 16x52 cm
Inv. no. 8639
Provenance unknown.

Pietro di Cristoforo Vannucci
called Perugino
(Città della Pieve c
1448-Fontignano 1523)

Visitation
Wood, 32x34 cm
Inv. no. 8654
From the convent of the nuns
of Crocetta in Florence.

Florentine painter of the late
15th century
*Man of Sorrows between the Virgin
and St John*
Wood, 97x71 cm
Inv. no. 8623
From the church of San
Girolamo sulla Costa in
Florence.

Room 3

Follower of Cosimo Rosselli
(Gherardo di Giovanni ?)
(Florence 1475/80)
*The Virgin and the Young St John
in Adoration of the Christ Child*
Wood, 207x204 cm
Inv. no. 8634
From the convent of Santissima
Annunziata in Florence.

Lorenzo di Credi
(Florence 1458/59-1537)
*The Virgin, St Joseph and Two
Angels in Adoration of the Christ
Child*
Wood, 138x144 cm
Inv. no. 8661
From the convent of the
Murate or the convent of
Santissima Annunziata in
Florence.

Cosimo Rosselli
(Florence 1439-1507)
*Saints John the Baptist, Barbara
and Matthew*
Wood, 215x219 cm
Inv. no. 8635
From the convent of Santissima
Annunziata in Florence.

Attributed to Sandro Botticelli
(Florence 1455-1510)
*Madonna and Child ("Madonna
del mare")*
Wood, 40x28 cm
Inv. no. 8456
From the convent of Santa
Felicita in Florence.

Sandro Botticelli and assistants
*Madonna and Child with Saints
Dominic, Cosmas, Damian, Francis,
Lawrence and John the Baptist*
Canvas, 117x205 cm
Inv. no. 4344
From the oratory of the castle
of Trebbio in Mugello.

Jacopo del Sellaio
(Florence 1441-1493)
*Deposition with Saints James,
Francis, Michael and Mary
Magdalen*
Wood, 172x175 cm
Inv. no. 5069
From the church of San Jacopo
de' Barbetti in Florence.

Raffaellino del Garbo (Raffaello
de' Carli or de' Casponi)
(Florence c 1470-1524)
Resurrection
Wood, 177x187 cm
Inv. no. 8363
From the Capponi Altar in San
Bartolomeo at Monteoliveto
near Florence.

Cosimo Rosselli
*Moses and Abraham
David and Noah*
Wood, 20.5x57 cm each
Inv. nos. 8632, 8633
Provenance unknown.

Florentine artist of the second
half of the 15th century
God the Father
Wood, 66x133 cm
Inv. no. 8631
From the monastery of Santa
Maria del Carmine in Florence.

Jacopo del Sellaio
Entombment
Wood, 38x42.5 cm
Inv. no. 8655
From the convent of Santa
Maria di Lapo near Florence.

Biagio d'Antonio
(Florence c 1445-1510 ?)
*The Angel of the Annunciation
God the Father
The Virgin of the Annunciation*
Wood, 33x117 cm
Inv. no. 8619
Provenance unknown.

Bartolomeo di Giovanni
(Florence, documented from
1448 to 1511)
*St Jerome in Penance
Deposition
Stigmatization of St Francis*
Wood, 28x54 cm each panel
Inv. nos. 8627, 8628, 8629
From the monastery of San
Marco in Florence.

Francesco Botticini
(Florence 1446-1497)
*The Apostle Andrew in Adoration
of the Cross*
Wood, 63x43 cm
Inv. no. 8656
From the monastery of Santa
Maria del Carmine in Florence.

Sebastiano Mainardi
(San Gimignano 1460-Florence
1512)
*St Stephen between Saints James and
Peter*
Wood, 175x174 cm
Inv. no. 1621
From the convent of Santa
Maria Maddalena de' Pazzi in
Florence.

Follower of Cosimo Rosselli
(Florence, second half of the
15th century)
Coronation of the Virgin
Wood, 154x92 cm
Inv. no. 490
Provenance unknown.

The Tribune of the *David*

As we have mentioned before, not only the Gallery of the *Prigioni* but also the Tribune of the *David*, meaning the two wings opening off to the left and right of the statue, was decorated with tapestries. They were extremely important sixteenth-century tapestries, woven in Florence; some of them belonged to a series that was originally used to decorate the apartments of Leo X in Palazzo Vecchio. After they were removed for protective reasons, their place was taken by Florentine paintings from the collections of the Accademia or transferred here for the occasion from the deposits of the Soprintendenza. The paintings are disposed in a more or less chronological order, starting from the righthand wall of the right transept. The works here are a continuation of the collection in the "Salone del Colosso."

The predella with *Stories of the Martyrdom of Saints* by Francesco Granacci was originally part of an altarpiece for the high altar of the church of Sant'Apollonia, today dismembered. The central panel is in England; at the Accademia there are six small panels, while another two are also in Florence, in the Berenson Collection at Villa I Tatti; others still are in Munich and elsewhere, up to a total of 15 pieces. The small panels cannot therefore have formed a traditional kind of predella, but a more complex type of decoration which has yet to be reconstructed (among other things, some panels are larger than others). Vasari mentions a drawing by Michelangelo for the central panel; and, in effect, despite the size of these small panels and also considering the four figures of saints now in Munich, Granacci's concept of space is here broadened. The elongated figures show the influence of Tuscan Mannerism, for the altarpiece probably dates from the 1530s.

Granacci had trained in the workshop of the famous Domenico Ghirlandaio and among his companions there was the son of the master, Ridolfo Bigordi, called Ridolfo del Ghirlandaio (Florence 1483-1561). His artistic production went through high periods and low ones, with some moments of excellence especially in his youth and early maturity, followed by a marked decline. The two panels with figures of *Angels* from the convent of Augustinian nuns of San Baldassare at Maiano are youthful works: their pleasant Raphael-like style dates them at the latest at 1508. There is here no trace of Ridolfo's attempts to imitate the work of the very interesting and unconventional painter Piero di Cosimo (in several other cases this has even led to mistaken attributions): the atmosphere is openly solar and luminous, and the mood is one of superior harmony.

Between the two panels a *Madonna and Child with the Young St John* by Giuliano Bugiardini (1475-1554) is one of the best works by this

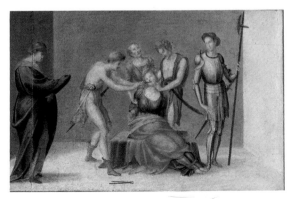 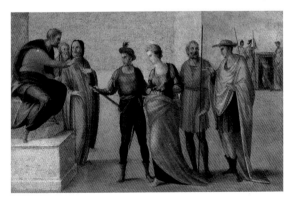

Francesco Granacci: Martyrdom of St Apollonia and another saint

43

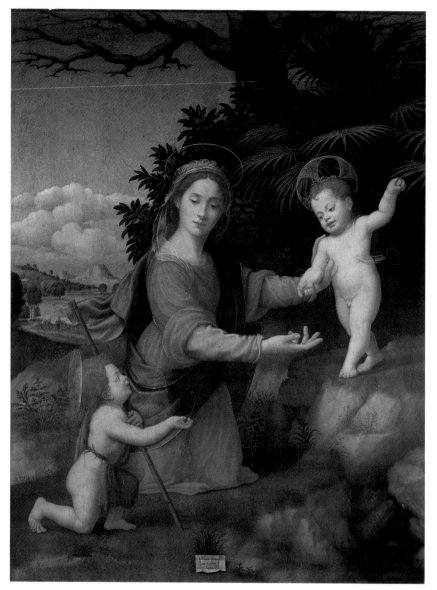

Giuliano Bugiardini:
Madonna and Child with the
Young St John

▷
Ridolfo del Ghirlandaio:
Praying Angels

artist who began his career in Ghirlandaio's workshop, but then moved on to Piero di Cosimo's. Signed and dated *Iulianus Florentinus faciebat 1520* the painting is a meditation on and a development of Raphaelesque themes derived from Fra Bartolomeo (notice in particular the asymmetrical composition, moving towards the upper righthand side). The stilted gesture of the Virgin, which is too forcefully elegant, is the same, only more emphasized, as that of the child St John; the little Jesus looks almost as though he is performing a dance step and leans on the palm tree with his left hand. But the pictorial technique is excellent.

The centre wall is for the most part taken up by a large panel painting, unfortunately severely damaged by badly handled cleanings in the nineteenth century. Painted by Agnolo Bronzino in 1564–65 for Grand Duke Cosimo de' Medici, the altarpiece comes from the church of the Franciscan monastery at Portoferraio on the island of Elba. Alas, this painting does not allow one fully to evaluate and appreciate the artist's qualities: certainly the decline noticeable throughout the painter's late work (he was born in Florence in 1503, where he died in 1572) is also present in this altarpiece. The various elements of the composition (the group in the foreground, the backdrop created by the characters in the background

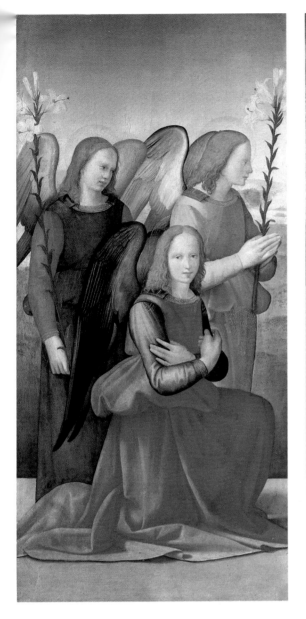

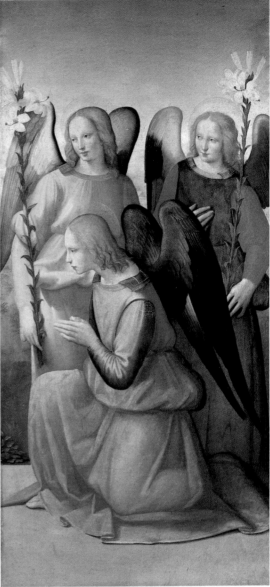

and the figures directly involved in the *Deposition from the Cross*) appear to be assembled rather schematically and not worked into an organic unity. But we must not forget that Bronzino's compositions can never be separated from his pictorical technique: it is only with the actual completion of the painted surface that the artist gives a meaning to his work, where the shining, enamel-like colours, bright but balanced with subtlety, are not just technical accomplishment, but an essential element of the whole. As we said above, the present conditions of the painting do not allow us to evaluate it according to this principle.

So in this work we shall be able only to admire the exquisite eloquence of Bronzino. The painting was intended to be meaningful and moving, perfectly in line with the principles expounded by the artistic Counterreformation. Thus we can understand the function of the two young men in the foreground, left and right: they are like the wings of the stage, enclosing the action and indicating it to the spectator and acting as intermediaries between him and the event. This also explains several of the figures' gestures, who are pointing, indicating, explaining, commenting, emphasizing. Eloquence is by this period an integral part of the work of art, and in order to move the spectator it is necessary for it to be not only

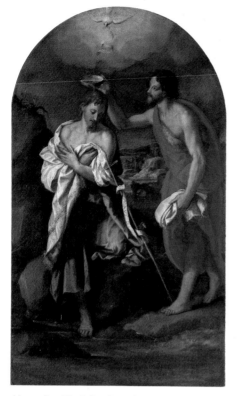

Alessandro Allori: Baptism of Christ

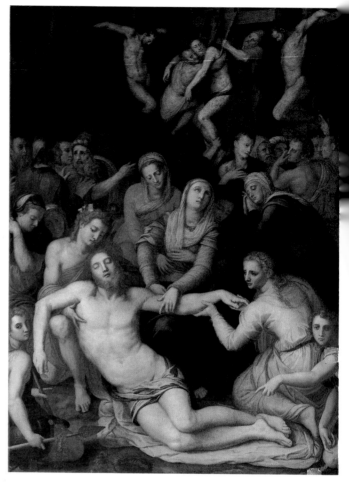

▷
Agnolo Bronzino: Deposition from the Cross

beautiful but also absolutely explicit.

Of the two paintings on either side of the Portoferraio *Deposition*, the *Annunciation* to the left is more worthy of note. It is the work of Alessandro Allori (Florence 1535-1607), the faithful pupil of Bronzino (or "creato" as they were called at the time) who was also his heir: he inherited not only all his worldly goods but also his workshop and his official position as Medici court painter, responsible also for the running of the important tapestry workshop. In this *Annunciation*, a work of excellent quality, Allori comes across in an almost domestic mood, psychologically of great intimacy. It comes from the Medici villa of Castello and was painted, as we can see from the inscription below the angel, very late, in 1603, four years before the artist's death. Notice the elegance of the skillful drawing, "virtuoso" but not ostentatious, and of the colours, intense but lacking in exterior brilliance; and the gesture of acceptance of the Virgin

is so natural, without any rhetorical pomposity. In this late work Allori shows that he has taken up the new trends of Florentine painting searching for a simpler and more natural art.

On the wall to the right of the *David*, in the middle there is a painting which is interesting for several reasons. The large *Venus and Cupid* was painted by Pontormo (Jacopo Carrucci, 1494-1557) based on a cartoon, that is a detailed preparatory drawing, specifically prepared by Michelangelo in 1533. This is evidence of the almost master/pupil relationship between Michelangelo and Pontormo and of the fact that the great artist saw in the Florentine Mannerist a painter well suited to express his own artistic intentions. The painting was intended for a bedroom of Bartolomeo Bettini's house, decorated with lunettes by Bronzino; but Alessandro de' Medici almost by force took it for himself, and Michelangelo complained bitterly and blamed the

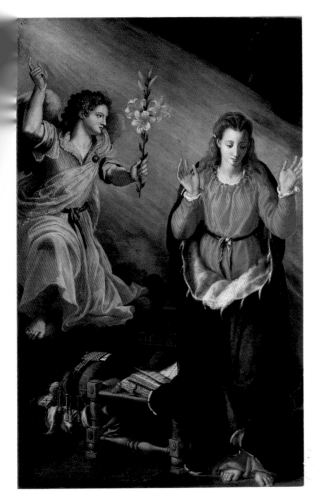

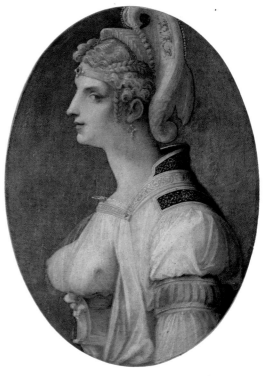

Michele di Ridolfo del Ghirlandaio: Ideal Portrait

<

Alessandro Allori: Annunciation

Pontormo: Venus and Cupid

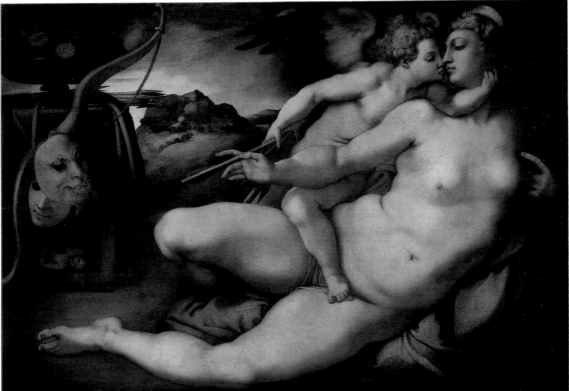

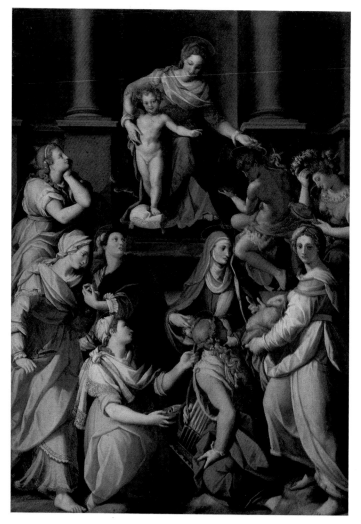

Alessandro Allori: Madonna and Child with Saints

▽

Francesco Foschi: Madonna and Child with the Young St John

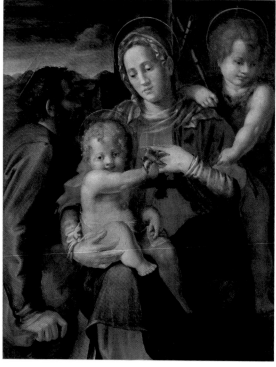

innocent Pontormo. Michelangelo had prepared a cartoon for Pontormo once before: a *Noli Me Tangere* which has not been identified with certainty. The *Venus and Cupid* shows Michelangelo's studies on the nude between stillness and motion, overcome by complicated torsions that are evidence of a state of inner restlessness. It is an extremely learned painting, full of iconographical references that can only be understood by scholars: it is very much the product of Florentine cultural circles, closely connected to the Academies (which makes its presence in this collection particularly appropriate). Michelangelo's cartoon partially conditioned Pontormo, making him emphasize the sculptural, three-dimensional quality of the figures which is not part of his artistic language, but does belong to Michelangelo's. The painting is indicative of a whole range of subjects that formed the object of

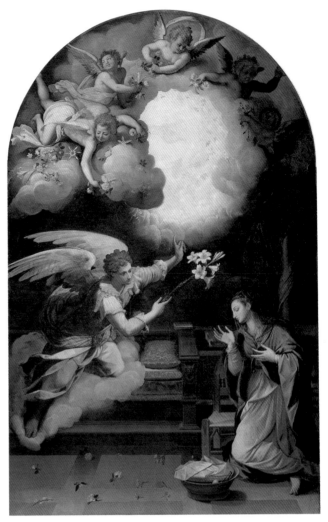

Alessandro Allori: Annunciation

▽

Cecchino Salviati: Madonna and Child with the Young St
John and an Angel

▽

Poppi: Allegorical Figure

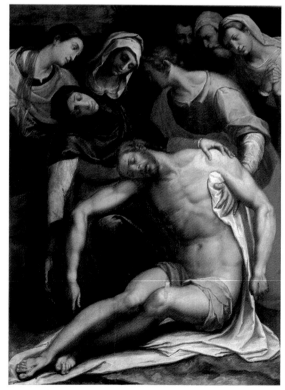

debate in cultural circles of Florence at the time.

The left arm of the Tribune contains paintings from the second half of the Cinquecento, mostly the work of artists inspired by Michelangelo (and this is the reason they are placed here) who thought of him as the god of painting, the genius to imitate or at least to begin from even if, like Santi di Tito, they later moved away. On the right-hand wall there are three large altarpieces by Alessandro Allori, the *Madonna and Child with Saints*, painted in 1575 for the Hospital of Santa Maria Nuova, the *Coronation of the Virgin*, painted in 1593 for the high altar of the church of Santa Maria degli Angeli, and, in the centre, the large *Annunciation*, painted in 1579 for the convent of the nuns of Montedomini, as the author stated in his *Libro dei Ricordi* (Book of Memoirs). When compared to the later and smaller *Annunciation* we mentioned above, here the artist is still fully involved with Mannerism: the poses and gestures are broader and more explicit, the modelling is exquisite and the colours are silvery and enamel-like. But this fact should not make us think that the quality of the painting is for this reason inferior. They are on different levels: the artistic principles are different, but the painting is nonetheless a masterpiece, for the artist has fully achieved what he set out to do. A recent cleaning has made its intrinsic qualities even more appreciable.

Other works belonging to this same artistic climate are, for example, the altarpiece by Maso da San Friano and the extraordinary one (at present badly in need of restoration) by Carlo Portelli. But here I shall only describe two paintings by Santi di Tito (Sansepolcro 1536 – Florence 1603), the *Deposition* and *Christ's Entry into Jerusalem*. These works are excellent examples of the transition brought about by Santi di Tito at first, and immediately afterwards by Cigoli and Empoli as well, in the last quarter of the Cinquecento, from a cold, intellectual painting, concerned with "virtuoso" renderings and searching for technical difficulties, with abstruse colour schemes, towards a simpler and more natural art, backed by a more genuine and not merely conventional

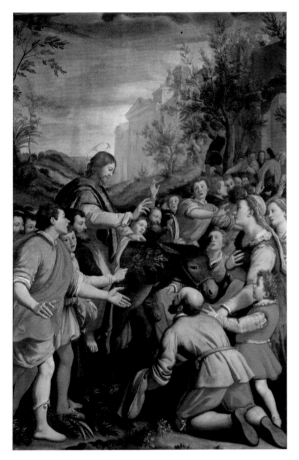

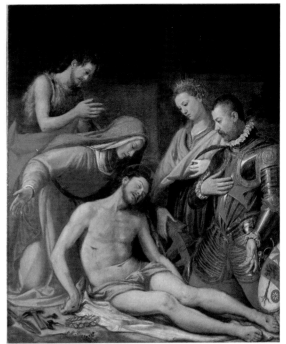

Santi di Tito: Deposition from the Cross

Santi di Tito: Christ's Entry into Jerusalem

◁
Carlo Portelli: The Immaculate Conception

◁
Stefano Pieri: Deposition

religious feeling, that could readily be understood by everyone. See, for example, the simplicity of the composition in the *Deposition*, from the Chapel of the Fortezza da Basso (compare it, say, to the painting of the same subject by Bronzino), the natural poses and gestures, the more intimate mood. Even the portraits (see the extraordinary portrait of the patron) are totally lacking in idealization; they are quite simply and truthfully naturalistic portraits.

The *Entry into Jerusalem* comes from the high altar of the church of the monks of Monteoliveto. It was painted in the 1570s and, even though there are many more figures and the composition is much broader, here too the artist avoids "virtuoso" flourishes of expressions and movements that were typical of Mannerism; the subject is dealt with by means of a simple narration of an event from daily life, observed and recounted with objectivity. The other paintings in the left wing of the Tribune can be examined and compared bearing in mind the two opposite poles of the work of Allori and Santi di Tito.

Francesco Granacci
(Villamagna 1469/70-Florence
1543)
The Martyrdom of St Apollonia
Wood, 40x59 cm
Inv. no. 8692
*The Disputation of St Catherine of
Alexandria*
Wood, 41x61 cm
Inv. no. 8691
The Martyrdom of St Catherine
Wood, 41x61 cm
Inv. no. 8690
A Saint in front of a Judge
Wood, 39x55 cm
Inv. no. 8694
The Martyrdom of a Saint
Wood, 39x55 cm
Inv. no. 8693
The Martyrdom of a Saint
Wood, 39x58 cm
Inv. no. 8695
Purchased by the State.

Ridolfo del Ghirlandaio
(Florence 1483-1561)
Three Praying Angels
Wood, 111x54 cm
Inv. no. 8649
From the convent of the
Augustinian nuns at San
Baldassare at Maiano, near
Florence.

Giuliano Bugiardini
(Florence 1475-1554)
*Madonna and Child with the Young
St John*
Wood, 117x88 cm
Inv. no. 3121
Provenance unknown.

Ridolfo del Ghirlandaio
Three Praying Angels
Wood, 111x54 cm
Inv. no. 8648
From the convent of the
Augustinian nuns at San
Baldassare at Maiano, near
Florence.

Alessandro Allori
(Florence 1535-1607)
Baptism of Christ
Wood, 166x98 cm
Inv. no. 2175
Provenance unknown.

Agnolo Bronzino
(Florence 1503-1572)
Deposition from the Cross
Wood, 350x233 cm
Inv. no. 3491
From the church of the Friars
Minor in Portoferraio, Elba.

Alessandro Allori
Annunciation
Wood, 162x103 cm
Inv. no. Dep. 131
From the Villa Reale in
Castello.

Michele di Ridolfo del
Ghirlandaio
(Florence 1503-1577)
Ideal Portrait

Wood, 76x56 cm
Inv. no. 6072
From the Guardaroba
Granducale.

Jacopo Carrucci called
Pontormo
(Pontorme 1494-Florence
1557)
Venus and Cupid
Wood, 127x191 cm
Inv. no. 1570
Provenance unknown.

Michele di Ridolfo del
Ghirlandaio
Portrait of a Young Lady
Wood, 76x56 cm
Inv. no. 6070
From the Guardaroba
Granducale.

Alessandro Allori
Madonna and Child with Saints
Wood, 411x289 cm
Inv. no. 3182
From the Hospital of Santa
Maria Nuova in Florence.

Stefano Pieri
(Florence 1542-1629)
The Sacrifice of Isaac
Canvas, 240x160 cm
Inv. no. 2133
From the Guardaroba
Granducale.

Francesco Foschi
(Florence 1502-1567)
*Madonna and Child with the Young
St John*
Wood, 97x78
Inv. 235 blue, 302 yellow
Provenance unknown.

Alessandro Allori
Annunciation
Canvas, 445x285 cm
Inv. no. 8662
From the convent of the nuns
of Montedomini in Florence.

Francesco Rossi called Cecchino
Salviati
(Florence 1510-1563)
*Madonna and Child with the Young
St John and an Angel*
Wood, 104x82 cm
Inv. no. 6065
Provenance unknown.

Tommaso Mazzuoli called Maso
da San Friano
(Florence 1531-1571)
The Holy Trinity and Saints
Wood, 294x170 cm
Inv. no. 2118
From the Chamber of
Commerce, Florence.

Alessandro Allori
Coronation of the Virgin
Wood, 413x283 cm
Inv. no. 3171
From the Hospital of Santa
Maria Nuova in Florence.

Michele di Ridolfo del
Ghirlandaio
St Barbara
Wood, 198x156 cm
Inv. no. 5868
From the chapel of the Fortezza
da Basso in Florence.

Florentine painter of the second
half of the 16th century
Allegory of Fortitude
Wood, 187x142.5 cm
Inv. no. 8024
From the Guardaroba
Granducale.

Cosimo Gamberucci
(Florence 1565-1621)
St Peter Heals the Lame Man
Wood, 408x260 cm
Inv. no. 4631
From the church of San Pier
Maggiore in Florence.

Francesco Morandini called
Poppi
(Poppi 1544-Florence 1597)
Allegorical Figure
Wood, 129x103 cm
Inv. no. 9287
Purchased on the international
market.

Carlo Portelli
(Loro Ciuffenna c
1510-Florence 1574)
The Immaculate Conception
Wood, 410x248 cm
Inv. no. 4630
From the church of Ognissanti
in Florence.

Stefano Pieri
Deposition
Wood, 171x127 cm
Inv. no. 1595
Provenance unknown.

Santi di Tito
(Sansepolcro 1536-Florence
1603)
Christ's Entry into Jerusalem
Wood, 350x230 cm
Inv. no. 8667
From the church of the
monastery of Monteoliveto near
Florence.

Santi di Tito
*Deposition from the Cross with the
Virgin, Saints John the Baptist,
Catherine of Alexandria and a
donor*
Wood, 200x168 cm
Inv. no. 4637
From the chapel of the Fortezza
da Basso in Florence.

"Sale Bizantine"

These three rooms can be reached from the lefthand side of the left transept of the Tribune of the *David*. They are called "Sale Bizantine" or Byzantine Rooms because they house the oldest paintings of the collection, some of which date from the second half of the thirteenth century. Whether it is historically justified to define them Byzantine is a matter that is still actively debated among scholars. Without going into specific details, we can say that they are works that date from before the revolution brought about by Giotto beginning in the last decade of the thirteenth century; they therefore belong to a traditional, and largely conventional, art form (and it is in this sense that the connection with the culture of Byzantium seems justified, since it was for centuries and not only artistically always the same and incapable of renewal). Their characteristic is one of "pure" icons, that is of images that are the object of prayers; their sacredness is never questioned by those who pray and there is no two-way psychological exchange. Between the image and he who prays there remains an unsurmountable distance, as between the human and the divine. This is the period—the second half of the thirteenth century—when the first attempts at overcoming this distance take place.

One can begin to see these characteristics in the *Mary Magdalen with Stories of her Life* on the righthand wall in the first room, just beyond the door leading to the room on the right. Starting from this painting, scholars have reconstructed a group of works that are to be attributed to an artist working in Florence from the mid-thirteenth century till about 1280; he has been conventionally called the "Maestro della Maddalena." This artist obviously had a very active workshop which tried to soften the rigidity of Byzantine figures and create a gentler physical and psychological effect so as to allow for a closer relationship with the viewer, since this was clearly a need that was beginning

to be felt at the time. A comparison with the other thirteenth-century paintings in this room will illustrate this more clearly than words.

The earliest mention we have of this painting (1791) tells us it was in the vestibule of the Library of the Convent of Santissima Annunziata; its earlier location is unknown. The Saint is seen frontally, clothed only in the long hair that has grown during her stay in the desert. Her right hand is held open with the palm facing the spectator; her left hand holds a scroll in leonine verse with the following inscription: *Ne desperetis / vos qui peccare soletis / Exemploque meo / vos reparate Deo* (Do not despair, you who are wont

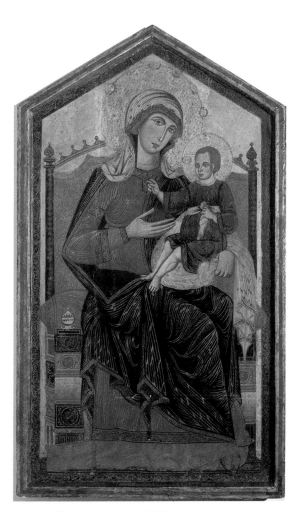

Guido da Siena: Madonna and Child

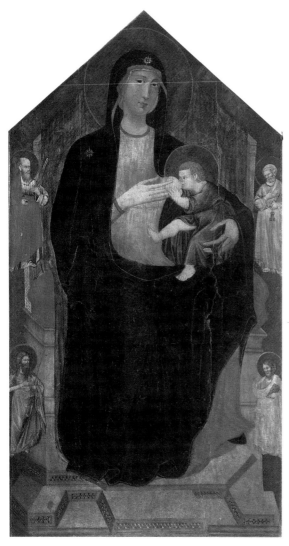

Master of San Gaggio: Madonna and Child with Saints

▷
Maestro della Maddalena: Mary Magdalen in Penance and
Eight Stories from her Life

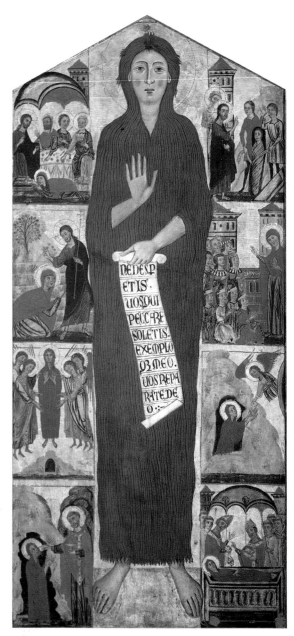

to sin, and, following my example, entrust yourselves to God). This is not the right place in which to reconstruct the history of the iconography of Mary Magdalen, one of the most interesting iconographies of our cultural history, also in view of the fact that it contains elements pertaining to at least three other saints. The version accepted by the present painting is that Mary Magdalen was the sister of Lazarus (and therefore perhaps the cousin of Jesus), a sinner who repented and became a hermit; she died in the South of France, near Marseilles. The most important cycle of paintings of stories from her life is in the lower church in Assisi. The eight scenes around the figure of the saint, starting from top left, can be interpreted as representing *Mary Magdalen in the House of the Pharisee*, the *Resurrection of Lazarus*, *Noli Me Tangere*, *Mary Magdalen Teaching the Dogmas of the Faith in Marseilles*, the *Saint Carried into the Desert by Angels*, *Receiving Food from an Angel*, *Receiving Communion from the Bishop Saint Maximinus*, and *Mary Magdalen's Funeral*. The painting belongs to the last years of the artist's activity, around 1280.

On the righthand wall, before the door, a *Madonna and Child with Saints* already shows a different art form, much closer to Giotto's

Pacino di Bonaguida: Crucifixion with the Virgin and Saints

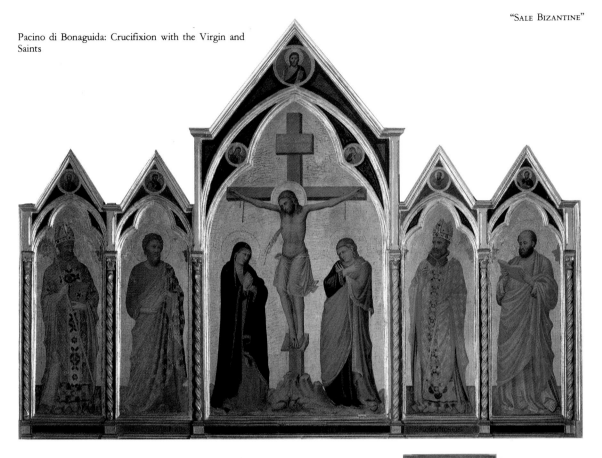

world. It is the work of the so-called Master of San Gaggio (and this is the painting that gives him his name, since it was originally in the Monastery of San Gaggio), and dates from the 1290s. Notice how the image begins to show subtle attempts, almost like irresistible temptations, at establishing a relationship with space that is different from the Byzantine stark frontality.

On the wall opposite the *Mary Magdalen* there is a large panel with an extremely complex subject. It is one of the most interesting paintings in the whole Gallery, and it portrays the *Tree of Life*, painted by the Florentine Pacino di Bonaguida around 1310. This artist worked as a painter and a manuscript illuminator in the first half of the Trecento in Florence; his activity has been reconstructed starting from the signed polyptych to the left of the entrance to this room, which was originally on the high altar of the church of San Firenze. This *Tree of Life*, which was splendidly restored in 1985, is inspired by the iconography that was laid down by the Franciscan friar Saint Bonaventure in his *Lignum Vitae*. Christ is crucified on a tree with twelve branches.

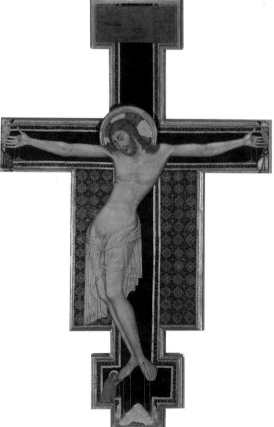

Sienese painter of the second half of the 13th century: Painted Crucifix

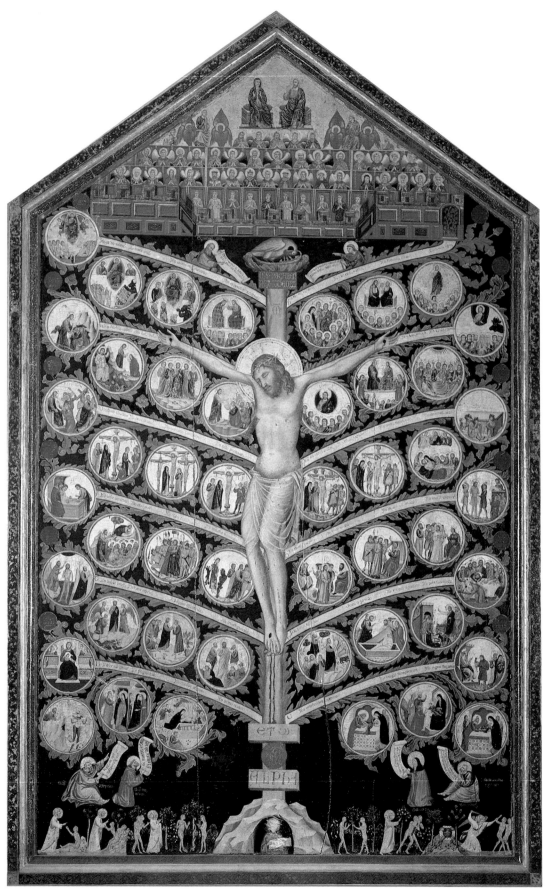

◁
Pacino di Bonaguida: Tree of Life

Pacino di Bonaguida: Tree of Life, details

The four lower ones have roundels hanging from them illustrating stories of Christ's origin, childhood and public life; the four central ones show stories of the Passion; the four top ones show episodes of the glorification of Christ. At the foot of the tree, to the left and the right, are Moses, St Francis, St Clare, and St John the Evangelist. Still lower, along the border of the painting, are the stories from Genesis, from the Creation of Man to the Fall. Above the trunk of the tree there is a pelican's nest (a well-known symbol of Christ, since, according to legend, it fed its young with its own blood), and to the left and right Saints John the Evangelist and Francis. Further above there are groups of angels, Saints and Blessed, crowned by the figures of Christ and the Virgin.

This painting is typical of a common medieval practice, that is of the literal illustration of a written text, as a visual exemplification

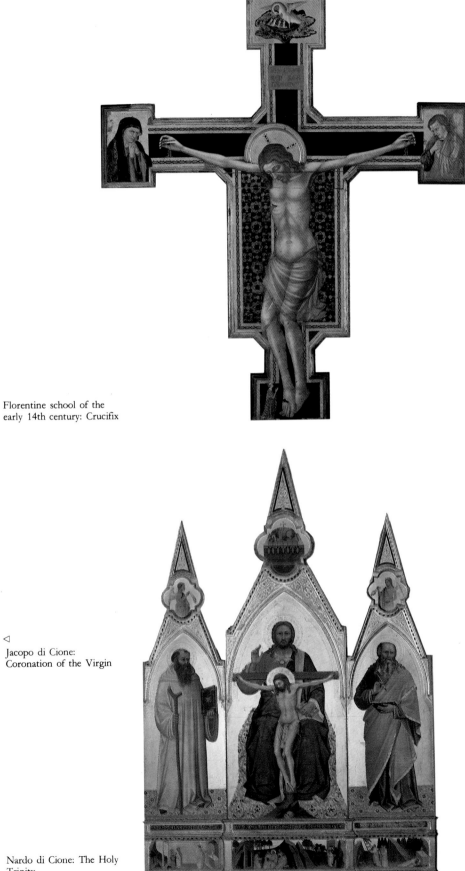

Florentine school of the
early 14th century: Crucifix

△
Jacopo di Cione:
Coronation of the Virgin

Nardo di Cione: The Holy
Trinity

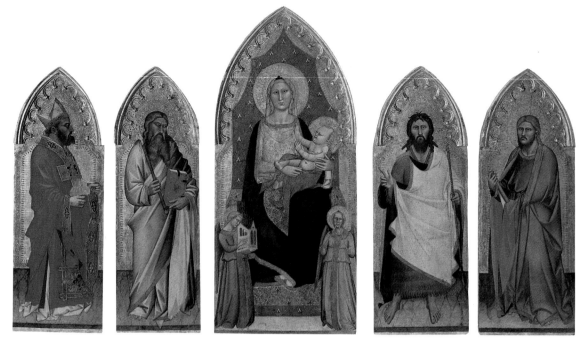

Bernardo Daddi: The Legend of the Three Dead Men

△
Andrea Orcagna: Madonna and Child with Angels and Saints

of its content for the illiterate populus (hence the work of art as *Biblia Pauperum*, the Bible of the Poor). The artist's intention here is to emphasize the activity of the Franciscan order in the illustration and spread of religion, and that is why he has followed the text of Bonaventure and has painted the figure of Francis twice. The style itself is fascinatingly innovative and elegant, and is very reminiscent of the art in which Pacino excelled, that of manuscript illumination.

In the room that opens off to the left, the paintings belong to the middle of the Trecento and beyond. The interesting polyptych, painted on both sides, that stands on a trestle, probably can be dated still in the second quarter of the fourteenth century. It is attributed to the anonymous Master of the Dominican Effigies (from a painting on that subject in the church of Santa Maria Novella). Although we know nothing about where it came from, it must have been intended for a high altar that the public could walk around and admire both sides of (among other similarly designed polyptychs are the two produced by Giotto's workshop for Santa Reparata, the old Cathedral of Florence, and St Peter's in Rome). The *Madonna and Child* was on the front, while the *Coronation* was on the reverse. The portrayal of St Romualdo indicates perhaps that it was originally intended for a church consecrated to that saint.

In the same room there is an excellent example of the art of the three Orcagna brothers: Andrea di Cione, the eldest and most famous, the elegant Nardo and the much younger Jacopo. They had the most important Florentine workshop active from the 1350s to the 1370s; they also produced works of sculpture (Andrea is the author of the celebrated marble tabernacle of Orsanmichele) in a style which echoed, at times

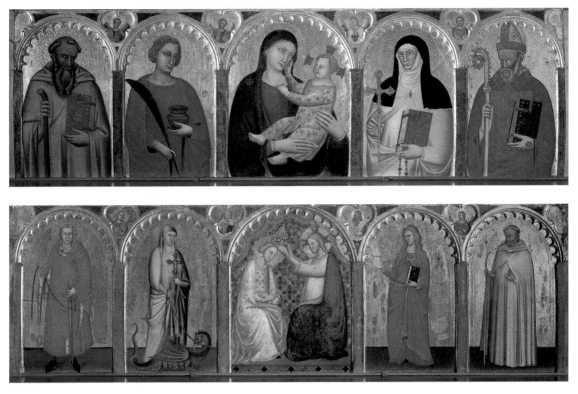

Master of the Dominican Effigies: Madonna and Child with
Saints; Coronation of the Virgin and Saints

almost too schematically, the sublime sim-
plicity of Giotto's spatial construction and
transformed it into rigidity. Andrea, who
died in 1368, was for a long time underrat-
ed but is now being gradually reappraised;
whereas the greatly lyrical characteristics, of
soft but bright colours, that distinguish the
art of Nardo have always been appreciated.
Jacopo is by far the lesser artist, for he
continued late into the century to use for-
mulas that were by then just tired repeti-
tions.

To the left there is a small polyptych by
Andrea, showing the *Virgin* in the centre,
between *Saints Andrew, Nicholas, John the
Baptist and James*. Originally in the church of
Santissima Annunziata, it can be dated at
the early 1350s. The figures are strongly
sculptural and their expressions thoughtful,
almost angry. The rigid spatial division
echoes the painting of the great Maso di
Banco, but lacks his colour variations. It is
a noble and intense art, with great expres-
sive power.

According to the inscription which can still
be seen in the lower part of the painting,
Nardo painted the polyptych next to it in
the last year of his life, 1365. It shows the
Trinity in the centre, between Saints Ro-
mualdo (left) and John the Evangelist. The
painting comes from the Convent of Santa
Maria degli Angeli which belonged to the
Camaldolensian order, as did St Romualdo.
The artist may have left the work partially
unfinished, but in any case the bright col-
ouring added to the severe structure is still
very noticeable, as is the softening of the
expressions, aimed at lyricism rather than at
dramatic effect. Also interesting is the
charming narrative quality of the stories
from the life of St Romualdo in the predel-
la.

To the right of the entrance one can admire
the imposing *Coronation of the Virgin* by Jaco-
po, the youngest of the three brothers. The
painting was finished after 1372, as we
know from our sources which also inform
us that originally the work had been en-
trusted to the painters Simone and Niccolò
(undoubtedly Niccolò di Pietro Gerini), but
was in the end carried out by Jacopo. It is
one of the most exemplary public works
produced in Florence in the Trecento. The
client was the Mint of Florence, which also
supplied three ledges to support the huge

painting decorated with the coats-of-arms of the Commune and of the Guilds of Calimala and the Moneychangers. The painting thus appears to be a hymn of praise to the city's Mint, a paean celebrating the florin, the Florentine coin that was famous throughout the world. The saints represented are the patrons and protectors of Florence; among them, John the Baptist and John the Evangelist. Above, the prophets Isaiah and Ezekiel.

Among the paintings in the third room, which lies to the right of the first one, the place of honour has been awarded to the huge painted *Crucifix* in the centre of the end wall. A much-needed cleaning and restoration would probably allow us to get a better idea of its extraordinary quality and to attribute it without doubt to the workshop of Bernardo Daddi, an artist of primary importance whom we shall discuss further below.

To the right, laid out according to the reconstruction made many years ago by Luisa Marcucci, is what is left in Florence of the decoration of the reliquary chest from the sacristy of the church of Santa Croce. (Two other panels are today in Berlin and two in Munich; all in all there were twenty-six). Painted by Taddeo Gaddi, one of Giotto's most talented pupils and followers, this decoration was placed on the outside of the cupboard containing two precious relics: a fragment of the True Cross and a thorn from Jesus's crown. We are not sure exactly how the panels were arranged and various theories have been proposed, but what is important here is the function of the work which is composed of two semi-lunettes (together they obviously formed a whole lunette even though this would, rather incongruously, show the *Annunciation* after the *Ascension*), and twenty-six multifoiled panels, that is having frames made up of straight and curved lines meeting at angles. In the panels there are episodes from the life of Christ (twelve remain in Florence) and of St Francis (there are ten left). To be dated around the early 1330s, these panels show that Taddeo was acquainted with the iconography of Giotto's works, in particular with the frescoes in the Arena Chapel in

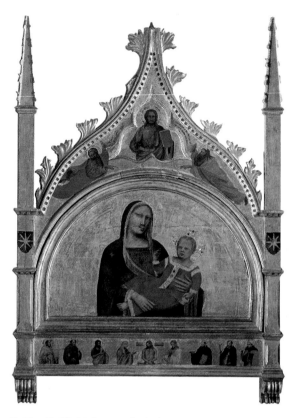

Taddeo Gaddi: Madonna and Child
Niccolò di Pietro Gerini: Christ Blessing and Man of Sorrows with Saints

▷
Taddeo Gaddi: Ascension and Annunciation

▷
Taddeo Gaddi: Stories from the Life of St Francis, The Chariot of Fire

Taddeo Gaddi: Stories from the Life of Christ, The Resurrection

Andrea di Bonaiuto: Saints Agnes and Domitilla

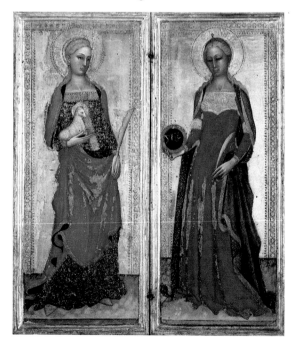

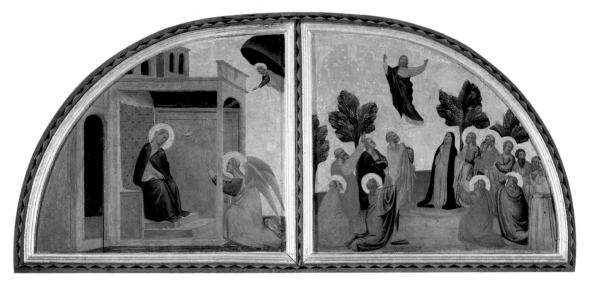

Padua, as far as the stories of Christ are concerned, and the frescoes in the upper church in Assisi, for the episodes from the life of Francis. Restricted by the small size of the panels and the necessarily limited field of action, Taddeo nonetheless manages to convert these difficulties to his advantage, creating simple but immediate action portrayals. The artist also shows his love of foreshortening (see the soldier to the right in the *Resurrection*) and of unusual settings (see the nocturnal scene of the *Chariot of Fire* in the stories of St Francis). In fact Taddeo is one of the greatest painters of the century as can be seen clearly from the frescoes in the Baroncelli Chapel, also in the church of Santa Croce. His ability to conceive grandiose scenes within wide spaces, executed with great expertise in brushwork and use of colour, make him an important artist, with a specific role in the development of Giottesque style and forms throughout the century (Taddeo died in 1366; his earliest works date from the early 1320s).

On the lefthand corner of the same wall a medium-sized panel portrays a *Man of Sorrows*, with the Virgin, Mary Magdalen and John the Baptist. It is signed and dated by Giovanni da Milano in 1365 and is one of the few works of this Lombard artist that can be dated with certainty. Giovanni arrived in Florence shortly before the middle of the Trecento and stayed in the city for about twenty years, until he moved to

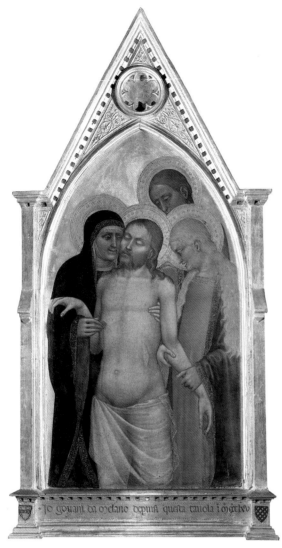

Giovanni da Milano: Man of Sorrows

almost hopeless, of the work communicate the tragedy, as does the livid colouring, the abandonment of Christ's body, concentrated in the two hands. So much so that, in front of this famous painting, one stops for a long time in meditation.

Giovanni da Milano carried out a cycle of frescoes in the apse of the sacristy of Santa Croce (Rinuccini Chapel). He never completed the work, probably because he was called to Rome by the pope; the decoration was finished by an artist conventionally called the Master of the Rinuccini Chapel. (Recently it has been suggested that this artist may have been Matteo Pacini.) The polyptych that one sees on the lefthand wall when one enters the room, showing the *Vision of St Bernard*, is usually attributed to this artist as well. It must have originally been painted for a Benedictine institution, for the saint belonged to that Order; it was probably the Campora monastery, where the painting was before it was transferred to the Badia and then to the Florentine Galleries in 1810. We see here St Bernard addressing the Virgin; to the left, Saints Benedict and John the Evangelist, to the right, Quentin and Galganus; the predella shows stories from the lives of these saints. The sublime style of Giovanni da Milano has been only partly understood and assimilated by this artist of rather limited talent. In any case, this excellently preserved painting is an interesting example of Florentine work around 1370: products of a very high technical level, extremely decorative works, with great immediacy in their narrative structure.

Rome to work on projects that unfortunately have not come down to us. Giovanni da Milano is unanimously considered one of the greatest painters of all times, and this painting is one of his masterpieces. It is more openly Gothic than the work of other Florentine artists and thus belies the Lombard origin of the painter. We find here the extraordinary use of chiaroscuro that is typical of Giovanni's work, together with the gradual changes in colour tones. The strong dramatic effect is further enhanced by the fact that it is merely suggested: the screams have frozen and do not leave the lips of the characters, for the artist knows that tragedy can best be conveyed through the means and techniques of art, rather than by a straightforward description. The dull tones,

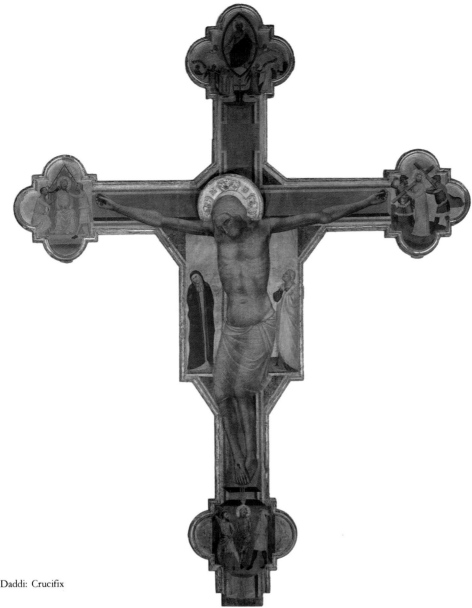

Bernardo Daddi: Crucifix

Room 1

Guido da Siena
(Siena, second half of the 13th
century)
Madonna and Child
Wood, 125x73 cm
Inv. no. 435
From the Murray Collection.

Pacino di Bonaguida
(Florence, documented from
1320 to 1339)
Madonna and Child
Wood, 75x46 cm
Inv. no. 6146
Provenance unknown.

Master of San Gaggio
(Florence, second half of the
13th century)

*Madonna and Child with Saints
Paul and John the Baptist, Peter
and John Evangelist*
Wood, 200x112 cm
Inv. no. 6115
From the monastery of San
Gaggio in Florence.

Maestro della Maddalena
(Florence, second half of the
13th century)
*Fragment of an altar frontal showing
St John the Evangelist and Stories
from his Life*
Wood, 67x60 and 67x62 cm
Inv. no. Dep. 121
From the convent of Santissima
Annunziata in Florence.

Maestro della Maddalena
Mary Madgalen in Penance and

Eight Stories from her Life
Wood, 164x76 cm
Inv. no. 8466
From the convent of Santissima
Annunziata in Florence.

Maestro della Maddalena
*Fragment of an altar frontal showing
St Joseph and stories from his life*
Wood, 67x60 and 67x62 cm
Inv. no. Dep. 122
From the church of San Michele
at San Salvi in Florence.

Florentine painter of the second
half of the 13th century
*Madonna and Child with Two
Angels*
Wood, 130x73 cm
Inv. no. 433
From the monastery of San

Francesco at San Miniato al
Tedesco in Florence.

Florentine painter of the second
half of the 13th century
*Madonna and Child with Two
Angels*
Wood, 97x64.5 cm
Inv. no. 9260
From the Venerabile Opera
Laicale of San Jacopo at Cozzille
near Florence.

Pacino di Bonaguida
The Tree of Life
Wood, 248x151 cm
Inv. no. 8459
From the convent of the Poor
Clares at Monticelli near
Florence.

Pacino di Bonaguida
Crucifixion with the Virgin and St John
Saints Nicholas, Florentius and Luke the Evangelist
Wood, 126x243 cm
Inv. no. 8568
From the high altar of the church of San Firenze in Florence.

Sienese painter close to Duccio di Boninsegna
(Siena, second half of the 13th century)
Painted Crucifix
Wood, 296x197 cm
Inv. no. 1345
From the monastery of the Spirito Santo on the Costa San Giorgio in Florence.

Room 2

Jacopo di Cione
(Florence, documented from 1368 to 1398)
Coronation of the Virgin with Prophets and Saints
Wood, 350x190 cm
Inv. no. 456
From the Officies of the Mint in Florence.

Puccio di Simone
(Florence, documented from 1343 to c 1362)
Madonna of Humility
Saints Lawrence, Onofrius, James and Bartholomew
Wood, 132x191 cm
Inv. no. 8569
From the monastery of San Matteo at Arcetri near Florence.

Bernardo Daddi
(Florence, documented from 1312 to 1348)
Madonna and Child
Wood, 170x98 cm
Inv. no. 3466
From the chapterhouse of the church of San Paolino in Florence.

Pacino di Bonaguida
(Florence, documented from 1320 to 1339)
Saints Nicholas, John the Evangelist and Proculus
Wood, 75x51 cm (each panel)
Inv. nos. 8698, 8699, 8700
From the convent of Badia in Florence.

Florentine school of the early 14th century
Crucifix with a figure in adoration
Wood, 308x229 cm
Inv. no. 436
From the church of San Pier Scheraggio in Florence.

Bernardo Daddi
Crucifixion

Cusp: *God the Father*
Wood, 125x59.5 cm
Inv. no. 8570
From the convent of Santa Maria del Carmine in Florence.

Bernardo Daddi
Coronation of the Virgin with Angels and 42 Saints
Wood, 186x270 cm
Inv. no. 3449
From the convent of Santa Maria Novella in Florence.

Nardo di Cione
(Florence, documented from 1342-died in 1366)
The Holy Trinity with Saints Romualdo and John the Evangelist
Predella: *Stories from the Life of St Romualdo*
Cusps: *The Lamb of God and Two Angels*
Wood, 300x212 cm
Inv. no. 8464
From the Ghiberti Chapel in the church of Santa Maria degli Angeli in Florence.

Andrea Orcagna (Andrea di Cione Arcangelo)
(Florence, documented from 1343-died in 1368)
Madonna and Child with Two Angels
Saints Andrew, Nicholas, John the Baptist and James
Wood, 127x56.5 cm (central panel); 104x37 cm (side panels)
Inv. no. 3469
From the church of Santissima Annunziata in Florence.

On the trestle to the left:
Master of the Misericordia
(Florence?, second half of the 14th century)
Stigmatization of St Francis
Birth of Christ
Conversion of St Paul
Wood, 50x94 cm
Inv. no. 8565
From the convent of the Poor Clares at Monticelli near Florence.

Bernardo Daddi
Crucifixion (recto)
St Christopher (verso)
Wood, 40x18 cm
Inv. no. 8563
From the monastery of San Gaggio in Florence.

Taddeo Gaddi
(Florence, documented from 1327-died in 1366)
Madonna Enthroned with Two Angels and Four Saints
Wood, 52x26 cm
Inv. no. Dep. 169
Provenance unknown.

Bernardo Daddi
Crucifixion
Madonna Enthroned
Wood, 33x22 cm each
Inv. nos. 8566, 8567

From the church of San Pancrazio in Florence.

Bernardo Daddi
The Horsemen of Death
The Legend of the Three Dead Men
Wood, 18x22 cm each
Inv. nos. 6152, 6153
From the church of San Pancrazio in Florence.

On the trestle to the right:
Master of the Dominican Effigies
(Florence, documented from 1320 to c 1350)
Madonna and Child
Saints Lucy, Benedict, Margaret and Zenobius
Coronation of the Virgin
Saints Julian, Martha, Mary Magdalen and Romualdo
Wood, 64x193 cm
Inv. nos. 4633, 4634
Provenance unknown.

Room 3

Taddeo Gaddi
(Florence, documented from 1327-died in 1366)
Madonna and Child
Niccolò di Pietro Gerini
(Florence, documented from 1368 to 1415)
Christ Blessing and Two Prophets (cusp)
Man of Sorrows with the Virgin and Seven Saints (predella)
Wood, 170x120 cm
Inv. no. 448
Provenance unknown.

Andrea di Bonaiuto
(Florence, documented from 1343 to 1377)
Saints Agnes and Domitilla
Wood, 66x28 cm (each panel)
Inv. no. 3145
From the Hospital of Santa Maria Nuova in Florence.

Master of the Infancy of Christ
(Florence, documented from 1360 to 1390)
Madonna and Child
Annunciation
Crucifixion with Saints
Wood, 35x60 cm
Inv. no. 8465
From the church of Santa Felicita in Florence.

Taddeo Gaddi
Stories from the Life of Christ
Stories from the Life of St Francis
Wood, 72x158 cm (lunette); 41x29.5/36.5 cm (panels)
Inv. nos. 8581-8593, 8594-8603
From the sacristy of the church of Santa Croce in Florence.

Giovanni da Milano
(Caversago, documented from 1346 to 1369)
Man of Sorrows

Wood, 122x58 cm
Inv. no. 8467
From the convent of San Girolamo sulla Costa in Florence.

Niccolò di Tommaso
(Florence, documented from 1339 to c 1376)
Coronation of the Virgin with Angels and Saints
Wood, 58x28 cm
Inv. no. 8580
From the monastery of San Domenico at Fiesole near Florence.

Florentine artist close to Nardo and Jacopo di Cione
(late 14th century)
Coronation of the Virgin with Saints and Angels
Cusps: *God the Father Imparting His Blessing*
Wood, 110x45 cm
Inv. no. 8579
From the monastery of San Matteo at Arcetri near Florence.

Bernardo Daddi
(Florence, documented from 1312 to 1348)
Crucifixion with the Virgin and St. John
On the arms of the cross: *Last Judgment, Christ Carrying the Cross, Mocking of Christ* and *Flagellation*
Wood, 350x275 cm
Inv. no. 442
From the church of San Donato in Polverosa near Florence.

Florentine painter of the second half of the 14th century
Madonna of Mercy
Wood, 63x34 cm
Inv. no. 8562
From the convent of Santa Maria at Candeli near Florence.

Jacopo di Cione
(Florence, documented from 1368 to 1398)
Madonna of Humility
Wood, 104x64 cm
Inv. no. Dep. 132
From the church of Santi Ilario ed Ellero at Colognole near Pontassieve.

Florentine painter close to Andrea di Bonaiuto
(Florence, second half of the 14th century)
Annunciation
Cusps: *Two Prophets*
Predella: *Adoration of the Shepherds, Adoration of the Magi* and *Presentation in the Temple*
Wood, 237x117 cm
Inv. nos. 6098, 455
From the church of Orsanmichele in Florence.

Master of the Rinuccini Chapel
(Florence, documented from
1350 to 1380)
*Saints Michael Archangel,
Bartholomew and Julian*
Wood, 156x87 cm
Inv. no. 6134
From the monastery of
Sant'Ambrogio in Florence.

Master of the Rinuccini Chapel
St Anthony Abbot Giving Alms
Wood, 39x33 cm
Inv. no. 460
Provenance unknown.

Master of the Rinuccini Chapel
The Vision of St Bernard
Cusps: *The Redeemer Blessing, the
Angel of the Annunciation, the
Virgin of the Annunciation*
Predella: *Stories from the Lives of
Saints Benedict, John the Evangelist,
Bernard, Quentin and Galganus*
Wood, 175x200 cm
Inv. no. 8463
From the convent of the church
of Badia in Florence.

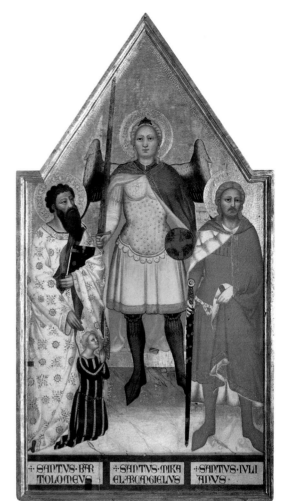

Master of the Rinuccini Chapel:
Archangel Michael

Master of the Rinuccini Chapel:
The Vision of St Bernard

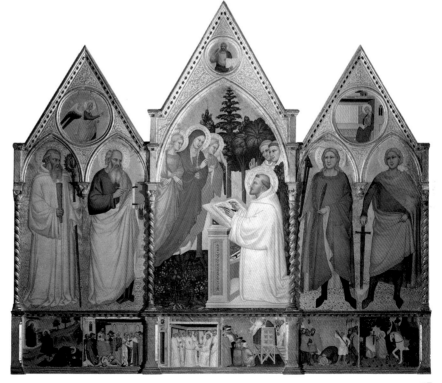

"Salone delle Toscane"

Within the overall project concerning the re-organization of the Accademia, in order to transform it into an institution housing and exhibiting neglected collections, the role of the "Salone delle Toscane" is one of extreme cultural importance. In this room the visitor will find information concerning the organization and activity of the Academy of Fine Arts in the nineteenth century, in its primary function of art-teaching institution thanks to the presence of famous Masters and of talented students destined to great careers; the exhibition also illustrates the grandducal policy of promotion and support of the arts and art-teaching.

At the same time, the room also offers a definitive location for some works which had been hidden away for a long time in deposits and storerooms. In particular, we find here the whole collection of original plaster models by Lorenzo Bartolini, finally exhibited to the public.

Bartolini was the most important European sculptor of the Romantic and post-Neoclassical period, of the generation, that is, after Canova, Thorwaldsen and Tenerani. Born near Prato in 1777, he moved to Paris in 1799 where he became a friend of the painters David and Ingres; in 1808 he became a Professor at the Academy of Carrara and the official sculptor of the Bonaparte family. He returned to Florence in 1815 but it was not until 1839 that he was awarded the professorship at the Academy that he undoubtedly deserved. He died in Florence in 1850. His art underwent a change around 1820, for he abandoned Neoclassical idealizations and turned towards nature studies; the best known example is his choice of a hunchback as a model for the figure of Aesop.

In this room are now collected the majority of his original plaster models that had been left in his workshop and only arrived at the Accademia after very complicated adventures. These are not casts made of his marble sculptures; on the contrary, the models were the most original and creative part of the sculptural process, because of the practice in the workshops of the time. For it was the master himself who moulded with his own hands the gipsum or plaster around an internal metal frame; his assistants would later copy the sculpture in marble. The metal nails that one sees on the models indicate certain fundamental points for the marble sculpture. We cannot here examine each work individually, for it would take much more space than we have; it will be enough to supply the public with some elements with which to evaluate and appreciate these neglected and generally unknown works, and with the knowledge that here is the evidence of a great period in Italian history of art, the last truly European one perhaps before Futurism. Once the novelty has been overcome, we are convinced that the excellent quality of these works will immediately become evident, and that the intention of the organizers will become clear: to place this collection in this grand room next to the Academy of Fine Arts, where Bartolini was the most illustrious Professor in the decade before the middle of the nineteenth century. We said at the beginning that Academy meant a school, and the negative connotations that the term has acquired must be changed to objective, or neutral. The art of the Maestro della Maddalena, at the end of the thirteenth century, exhibited in the Sale Bizantine; that of Cosimo Rosselli in the Sale Fiorentine; that of Giovanni del Biondo and Mariotto di Nardo, on the first floor; that of Granacci, of the late Bronzino, of Allori in the Salone del Colosso and in the Tribune of the *David*, are also academic, one might say. The idea that art can be taught and can be learnt is present throughout the Accademia, but it is best exemplified by the presence of one of the masterpieces of the only artist that was admired and copied by all his contemporaries but not matched by any: Michelangelo. With the setting up of the Salone dell'Otto-

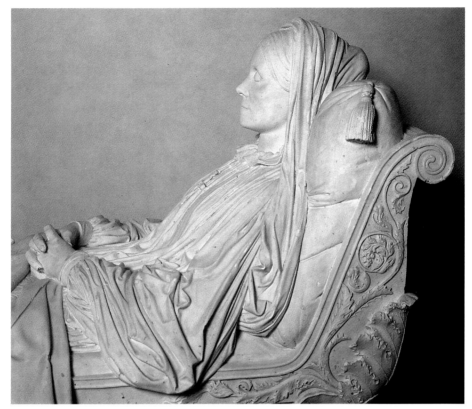

Lorenzo Bartolini:
Funerary monument
to Countess Sofia
Zamojska Czartoryski

Lorenzo Bartolini: Boy Pressing Grapes

Lorenzo Bartolini: Busts of Byron and Liszt

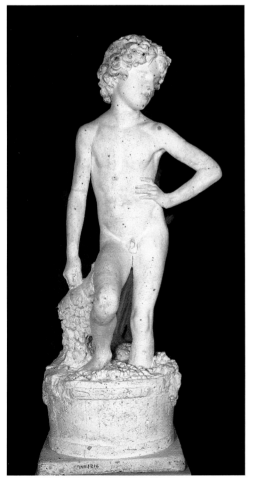

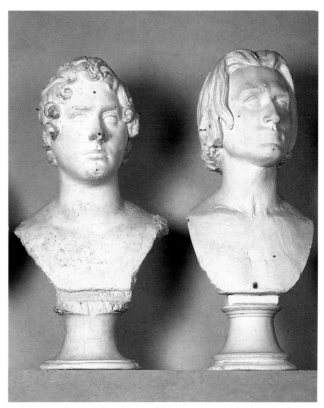

cento the Accademia finally attains that which it had always lacked: a distinct physiognomy, in which all its collections can identify themselves.

As well as Bartolini's models, among which we would like to mention those for the Demidoff monument, for the tombs of Leon Battista Alberti and Machiavelli, for Elisa Baciocchi's monument in Bologna and the impressive collection of portrait-busts including the one commissioned by Franz Liszt, this room contains also the collection of works by Luigi Pampaloni (1791-1847), a follower of Bartolini and also active in Florence. He too achieved fame throughout Europe (notice how many of his monuments, in particular the funerary ones at the end of the room, were commissioned by foreigners) and developed in a totally personal way Bartolini's naturalistic interest of the post-Neoclassical period. The plaster sculptures of the two artists make up one of the most important collections of its kind in the world; it is interesting not only for the intrinsic value of the works themselves, but also because it provides us with a documentation on how the production process of large marble sculptures and monuments took place.

Formerly the large room had been the women's ward of the Hospital of St Matthew. A detached fresco (but still in its original location) by Pontormo (c 1525) showing the hospital ward is of great documentary interest; it is almost a monochrome, all based on hues of green, and is on the lefthand wall near the entrance. Hanging on the walls, between the sculptures, and primarily on the short walls of the room, there is a splendid collection of nineteenth-century academic paintings, the work of the Academy's Professors or of exceptionally talented students who took part in the yearly competitions or who produced works in order to win scholarships. Many of these students were later to become Professors in the Academy. Some of the paintings, one will notice, are copies of famous originals of the past: the *Madonna del Sacco* by Andrea del Sarto in the cloister of Santissima Annunziata (above the entrance door), Titian's *Assumption* from the Frari Basilica in Venice

(just next to it). These paintings were made expressly for the Grand Dukes and their presence in this room is intended both to illustrate the trends of the age and to prove that a copy, as long as it shows clearly the styles of its period, can be as interesting and meaningful as an original. And in any case this is a custom that has been popular in all periods: for example, at the end of the fourteenth century and in the early fifteenth, Niccolò Gerini and Giovanni Toscani made copies of Giotto's works.

Among the paintings there are celebrated works by Luigi Mussini (*Sacred Music*, on the wall to the right of the entrance), his brother Cesare (*The Death of Atala*, above on the lefthand longer wall), by Giuseppe Fattori (*St John the Baptist before Herodias*, 1843, on the end wall), Benedetto Servolini (*The Death of Filippo Strozzi*, around 1835, on the righthand wall). They are for the most part strongly Romantic paintings, that translate into striking gestures and features the powerful emotions and passions of the Italian Risorgimento. In any case we think that they deserve to be observed and evaluated with the same attention that we grant to the works of previous centuries; in these paintings the relationship between art and civilization is the same as that of all other centuries and generations of our history.

The First Floor

It was only in June 1985 that the rooms on the first floor were opened to the public for the first time; here we can see the extremely rich collection of Florentine art dating from the late Trecento and early Quattrocento (a period preceded by the works in the Sale Bizantine below and continued by those in the Sale Fiorentine). In fact the art historical sequence is not entirely logical, nor is the distinction between the works in the Sale Bizantine, Fiorentine and first floor totally linear. This is because the organizers did not want to dismantle the set-up of the Sale Bizantine and Fiorentine elaborated by Luisa Marcucci in the 1950s, which in itself is an interesting object of study, especially if we consider that the modern concept of a museum requires it to be in a way a "museum of itself" and offer the public not so much its collections, but the way in which they have been assembled and exhibited over the course of time.

In the first room, at the top the stairs, two large painted *Crucifixes* hang opposite each other. The one on the wall facing the entrance wall is by Lorenzo Monaco (1370–1425), the most important artist in Florence in the transition period between

Mariotto di Nardo:
Madonna and Child
with Saints

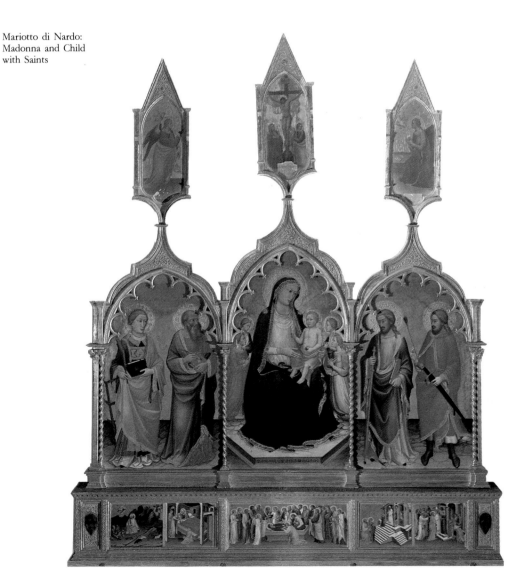

Giovanni Bonsi (?): St Lawrence

Lorenzo Monaco: Crucifix

the Gothic and the Renaissance; here in the Accademia he is represented with more paintings than anywhere else in the world. The *Crucifix* on the entrance wall was probably painted by Bartolomeo di Fruosino, in 1411, but certainly on designs by Lorenzo. Born as Piero di Giovanni, Lorenzo became a monk at Santa Maria degli Angeli after 1391, and his early training was in manuscript illumination, as is apparent by the superb mastery of the art of drawing evident in all his works. The first *Crucifix* was painted entirely by Lorenzo between 1405 and 1410; both probably come from the Hospital of Santa Maria Nuova.

Between the two doors on the righthand wall there is a large polyptych by Mariotto di Nardo (doc. in Florence 1394–1424) which has been finally reconstructed in all its component parts (predella and three

cusps). Commissioned by the Corsini family for the convent of San Gaggio, where it remained until 1810, the triptych is an early work by Mariotto and dates from 1393-4. The author is not a great artist, even though he was an active member of the more progressive Florentine cultural circles and was a close friend of Lorenzo Ghiberti. While in Florence there was a highly sophisticated style, such as the late-Gothic art of Lorenzo Monaco and Starnina, Mariotto continued well into the Quattrocento with a neo-Giottesque style, that looked back with nostalgia to Giotto's works, seeking perhaps in the severe sense of the great artist's spatial construction a climate of certainty that had been lost. Notice in this early polyptych the squat and immobile figures, substantially stiffened in the attempt to achieve an out-of-date objectivity.

Bernardo Falconi (?): St Romualdo's Dream

▽
Jacopo del Casentino: St Bartholomew and Angels

To the right of the stairs leading to the second room is a seated figure of *St Bartholomew* holding in his left hand the knife that would then be used to flay his skin. It was made for Orsanmichele but was removed as early as 1402, when all the paintings hanging from the pilasters were replaced by frescoes. It is the work of the painter Jacopo del Casentino, born in the 1290s or earlier still, if he is really the author of the frescoes in the Velluti Chapel in Santa Croce that can not be dated much after 1310. His activity is documented until 1358. This panel probably dates from the mid-1330s; it was painted for the Guild of the Pizzicagnoli (grocers).

On the other side of the stairs, a *Madonna and Child with Saints John the Baptist and Luke*, dated 1343, is the work of one of the greatest artists of the fourteenth century, the Florentine Bernardo Daddi. Scholars are beginning to re-evaluate his work within the context of Trecento painting, overcoming rather mediocre judgments on his art from the past (Longhi's definition of this artist as "a clockwork nightingale" is well known). The painting is badly damaged, the result of a disastrous cleaning operation. But it was decided to exhibit the work in any case, for its original importance and also for the didactic value that its condition of preservation offers the public. Giotto was still active at the time Bernardo painted this work; the basic Giottesque formula has been enriched with subtle colour variations, which have mistakenly led certain scholars

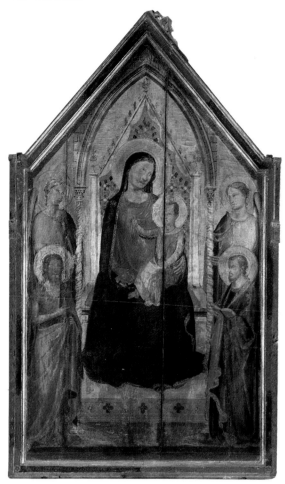

Bernardo Daddi: Madonna and Child with Angels and Saints

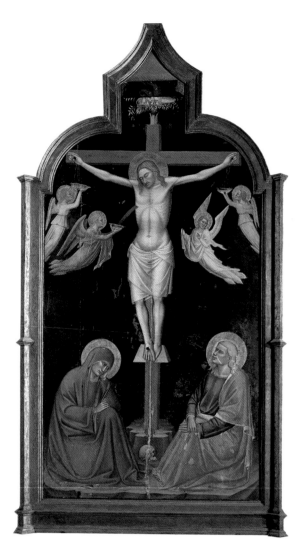

to speak of the influence of Sienese paint-ing. Bernardo's art is highly Gothic. The painting comes from the palace of the Guild of Doctors and Apothecaries in Florence.

Once we enter the large room the initial impression is one of extraordinary gran-deur: it houses the largest number of polyp-tychs all together in one room and the lighting, which has been carefully studied so as not to be overly bright, enhances the colours that do not stand out brazenly but rather appear to come to life gradually, as the observer's gaze rests on each painting in turn. In no other place is there a better exemplification of Florentine painting from the fourteenth and fifteenth centuries, and the visitor will become closely acquainted with artists such as Giovanni del Biondo, Rossello di Jacopo, Spinello Aretino, Nic-colò Gerini and Giovanni dal Ponte.

Here we can only mention but a few of the major works. Starting from the righthand wall there is the *Presentation in the Temple* by Giovanni del Biondo (documented in Flor-ence after 1356, died in 1398), from the convent of Santa Maria degli Angeli, dating from 1363. It shows us the undoubtedly prosaic art of a painter who generally pro-duced works of top quality craftsmanship. The figures practically fill the space, as though there were not quite enough; the six figures in the central scene almost ap-pear to be compressed. And yet this paint-ing shows us the narrative talent of the artist, who is telling a popular tale easily understood by all.

Next to it, the *Pentecost* originally on the high altar of the church of Santi Apos-toli, mentioned by Vasari (1568) as being the work of Spinello Aretino, is much more

Giovanni del Biondo: Presentation in the Temple

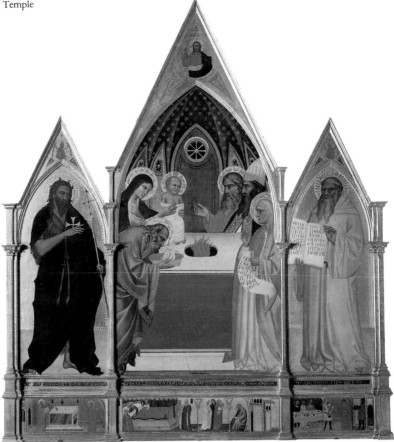

◁
Niccolò di Pietro Gerini:
Crucifixion with Saints

▽
Andrea Orcagna: Pentecost

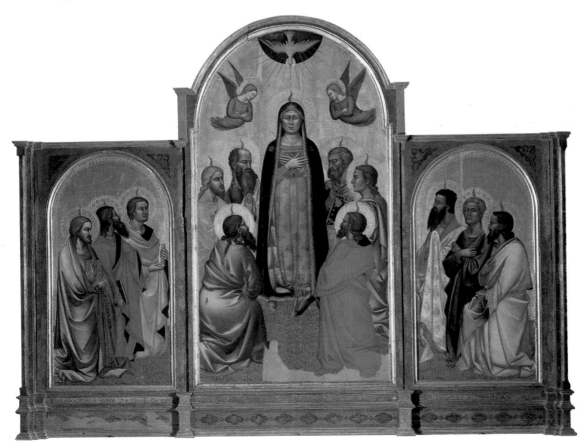

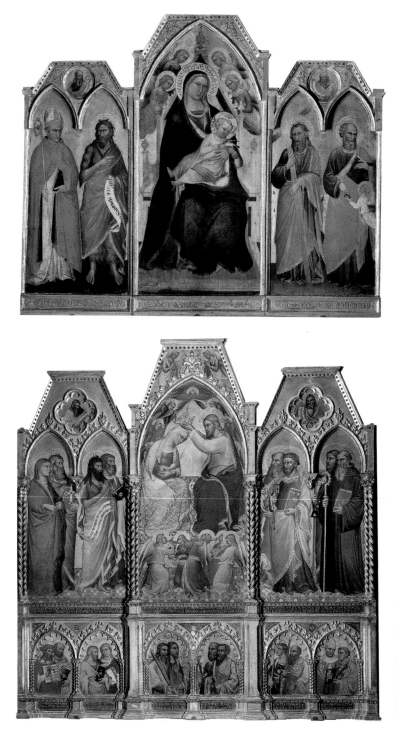

Spinello Aretino:
Madonna and Child
with Saints

▷
Follower of
Ambrogio di
Baldese: Madonna
and Child with
Saints

▷
Bicci di Lorenzo:
Madonna
Enthroned with
Angels and Saints

Niccolò di Pietro
Gerini, Spinello
Aretino and
Lorenzo di Niccolò:
Coronation of the
Virgin

likely to be a product of the workshop of Andrea Orcagna whom we talked about earlier, when dealing with the Byzantine Rooms. This painting, dating from the early 1360s, is remarkable for its compositional mastery, for the structural intelligence with which the artist solves the problem of placing in a small space the figures of the twelve Apostles and the Virgin. The rigid fronta-

lity—a conscious and probably deliberate archaism—shows a total understanding of the relationship between figure and psychology of vision, as we would say using modern terminology.

Further along, the *Madonna and Child with Angels and Saints Paolino, John the Baptist, Andrew and Matthew* from the church of Sant'Andrea in Lucca, is signed and dated

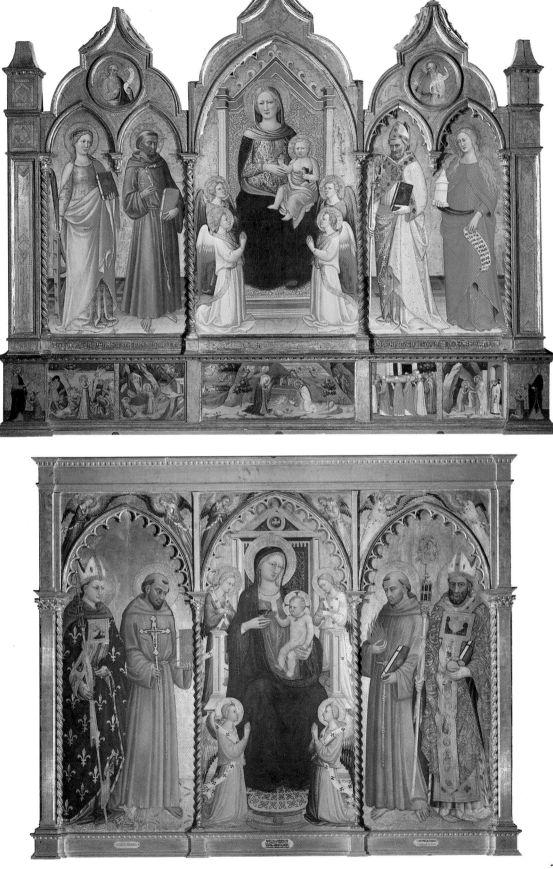

1391 by Spinello Aretino (born in Arezzo around 1352 – died before 1413). This is certainly a late work, perhaps carried out with the help of assistants, by an artist who was exceptionally important in the Tuscan artistic scene in the last quarter of the fourteenth century. In his travels from Arezzo to Florence, Lucca, Pisa and Siena, he created and spread a common language which took up certain Giottesque tendencies of the beginning of the century—in particular his rigorous spatial construction —animated them with various elements moving in different directions, with studies in use of colour and modelling that will later become fundamental in the development of the Late Gothic Florentine art of Lorenzo Monaco and Mariotto di Nardo.

Lorenzo Monaco: Agony in the Garden

◁
Master of the Griggs Crucifixion: Doubting Thomas

▷
Giovanni del Biondo: Annunciation

Lorenzo di Bicci: St Martin and the Beggar

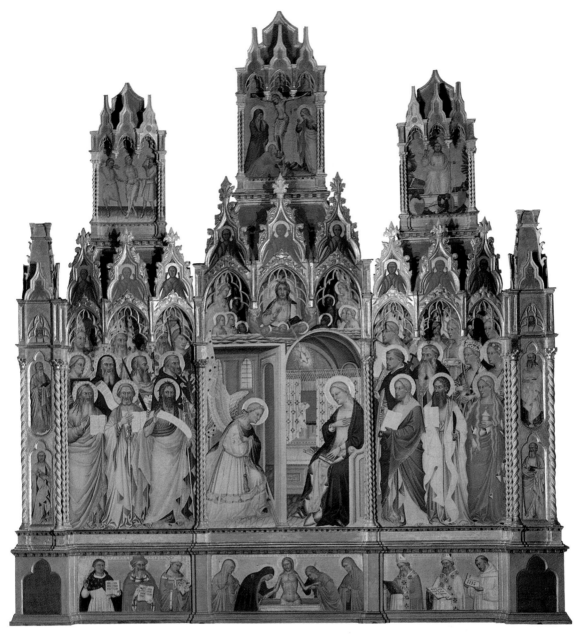

Next to it there is a large polyptych, which stood originally on the high altar of the church of Santa Felicita in Florence: the *Coronation of the Virgin* surrounded by several saints (see also the predella which in this painting is more important than usual). From a document of 1399 we learn that the painting was commissioned from a group of three artists: Spinello Aretino, Niccolò di Pietro Gerini and his son Lorenzo di Niccolò. We cannot here attempt to analyze the painting in detail, in order to establish which parts were painted by which artist; and anyway scholars are not entirely in agreement on the fact. We shall just mention that Boskovits thinks that Spinello is responsible for the central part and the righthand section. Unfortunately the polyptych has lost its cusps, yet it is still a magnificent example of the grandiose Late Gothic constructions created for the place of honour in a church. It is interesting to note that the Abbess of the Convent had commissioned the woodwork from two carpenters in 1395; it was only four years later that the structure was ready to be painted. The end wall of the huge room is taken up by one of the largest surviving polyptychs: the immense construction created around 1380-85 by Giovanni del Biondo for the

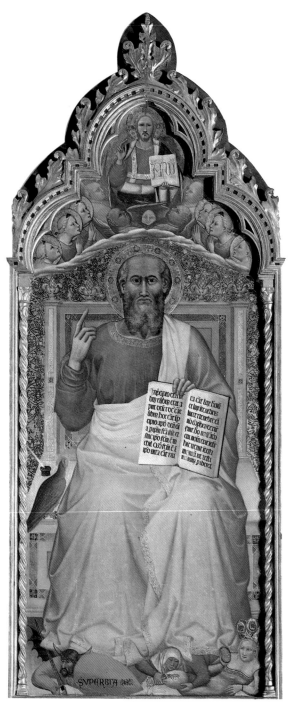

Giovanni del Biondo: St John the Evangelist Enthroned

of respect that the society of the past attributed to the arts as well as the perfection of the products that painters' workshops were able to create. Carpentry, architecture (every polyptych is in its own way an example of architecture), drawing, colour: a craftsmanship of the highest level, an absolutely admirable professionalism. Giovanni del Biondo's polyptych is also extremely well preserved: the slightly grey overtone is the result of the original protective covering of eggwhites, which spread over the surface a very hard layer that resisted against the elements (it is the removal of this layer, with solvents or even with scalpels, that usually caused such devastating damage to paintings). We advise the visitor to "read" this painting without haste, just as one reads methodically an interesting written page in order that nothing may escape.

On either side, the two saints (*John the Evangelist* by Giovanni del Biondo and *St Martin* by Lorenzo di Bicci) recall the *St Bartholomew* by Jacopo del Casentino we saw in the first room: they too were originally made for the pilasters of Orsanmichele.

Going back along the lefthand wall, beyond and important early polyptych by Lorenzo Monaco, a *Man of Sorrows with the Symbols of the Passion* by the same artist, and a polyptych by Rossello di Jacopo, we find the *Coronation of the Virgin* by Giovanni dal Ponte, or more correctly, Giovanni di Marco (Florence 1385 – after 1437). Of unknown provenance, this painting shows us an artist who, although he may be a little out-of-date in the context of the Florentine cultural world of the early Renaissance, has left us several fascinating works, elegantly designed and admirably executed. Giovanni usually succeeds in maintaining the sense of detail characteristic of Late Gothic art, blending it with a more flowing technique. The most striking element of this polyptych is the splendid figure of the Virgin, whose movement appears to echo the shape of the small twisted columns, in a composition of exquisite elegance.

Next to it is another *Coronation of the Virgin*, an immense polyptych from the Benedictine monastery of the Campora painted in 1420, as we can see from the date in the inscrip-

Cavalcanti altar in the sacristy of Santa Maria Novella. The impression is almost that of a Cinemascope screen, full of details. When it was in the Dominican church the faithful who stopped in reverence before it must have been stunned by the richness of its gold and its colours, by the majesty of the saints, by the exquisite images. Today, the modern visitor can admire the position

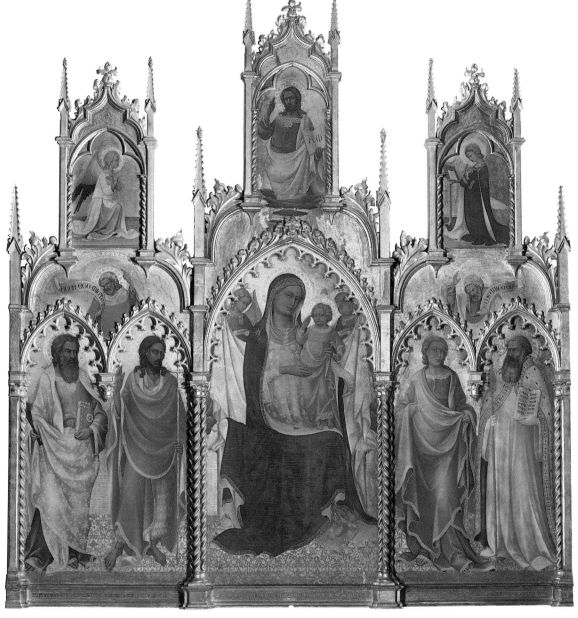

Lorenzo Monaco: Madonna and Child with Angels and Saints

tion, by Rossello di Jacopo Franchi (Florence 1377-1456). The historical position of this artist is rather similar to that of Giovanni dal Ponte, except that Rossello continued even further into the Renaissance to paint in a style that was still substantially Late Gothic. But in this masterpiece, thanks to a recent restoration, the splendid colours, at times cold, at times soft, and at times bright and spectacular, and the complexity of the overall plan, offer the spectator a religious celebration, a jubilation of the throng of saints taking part in the event. Further along, one of the most beautiful and interesting paintings: the *Annunciation* from the Leper Hospital of Sant'Eusebio sul Prato, with the coat-of-arms of the Da Montelatico family. We do not know the name of the artist of this painting that blends Spinello's and Agnolo Gaddi's Giottesque elements with intuitions of the Florentine Late Gothic; conventionally he is known as the Master of the Straus Madonna. From his works we know that he was active in Florence at the end of the fourteenth century and at the beginning of the fifteenth (his only dated painting is from 1405). This *Annunciation* was probably

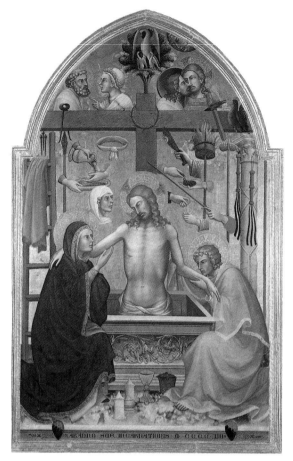

Lorenzo Monaco: Man of Sorrows with the Symbols of the Passion

painted around 1390-95; its colouring is delicate and extremely refined, with dull, almost ashen tonalities (obviously these artists were still following the lessons of Giovanni da Milano; see his *Man of Sorrows* in the Byzantine Rooms).

Since we cannot examine every painting, let us now move to the third room of the first floor. The rather crowded layout in this room is intended to allow the exhibition of the largest number possible of works of art; in this museum we have decided not to hang the paintings sparsely as is done in other major galleries, because what is primarily important here is their relationship to each other. On the righthand wall, above the niches, a group of paintings laid out in chronological order shows the Accademia's nucleus of works by Neri di Bicci. This artist, the son of Bicci di Lorenzo and grandson of Lorenzo di Bicci, ran an active workshop in Florence in the third quarter of the Quattrocento. His artistic talents

were definitely modest, but his production (as we know from a Book of Memoirs) was extremely wide spread and he fulfilled innumerable contracts and commissions. The last work chronologically is the *Annunciation* from the monastery of the Campora, dated 1464 and mentioned in the Memoirs. What is interesting here is the attempt to imitate the more learned examples of major contemporary art, in particular in the carefully studied architectural background.

In the niches below is the extremely important collection of Russian icons, brought to Florence by the Lorraine who became the rulers of Tuscany after the Medici died out in 1738. It has been suggested, although so far no evidence supports this theory, that this collection was a gift from Catherine the Great to her godson Pietro Leopoldo of Lorraine. In any case the collection (to which a couple of pieces were added later) is virtually unique in Italy. All the pieces were recently restored with great care. The most exceptional item is the *Menology* (that is the illustration of all the saints in the calendar) in two parts, one for the months from September to February, the other from March to August, produced in Moscow between the end of the sixteenth and the beginning of the seventeenth centuries. Almost all the other icons date from the seventeenth century and are the work of the so-called School of Stroganov. But, aside from the intrinsic artistic value of the collection, its very presence in the Florentine galleries is of exceptional historical importance.

On the wall opposite, at the centre, a splendid horizontal panel by the anonymous artist called the Master of the Straus Madonna, recently moved here from the deposits after being restored, illustrates the iconography of the *Man of Sorrows*, Christ together with the symbols of his Passion, as conceived at the very end of the fourteenth century or, more probably, in the first years of the fifteenth. (In the large room there is another extraordinary painting on this subject by Lorenzo Monaco). Till recently a simplified version of this work in a church near Arezzo was better known; we therefore thought that it would be useful to

Rossello di Jacopo
Franchi: Madonna
and Child with
Saints

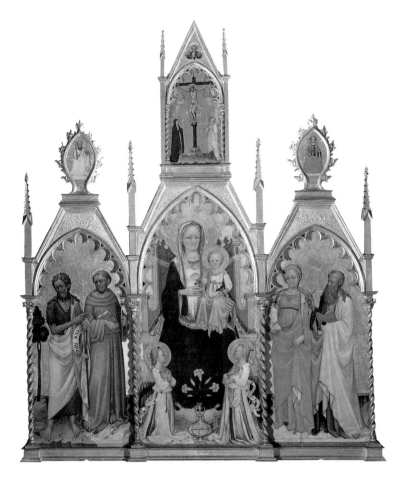

▽
Giovanni dal
Ponte: Coronation
of the Virgin with
Saints

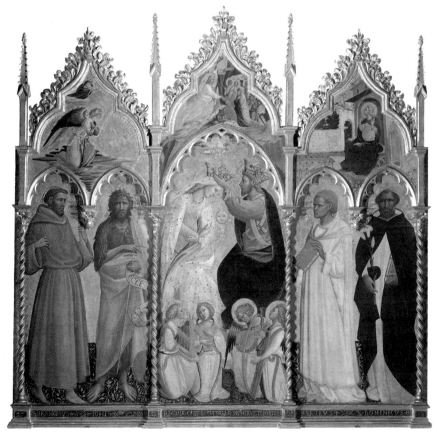

83

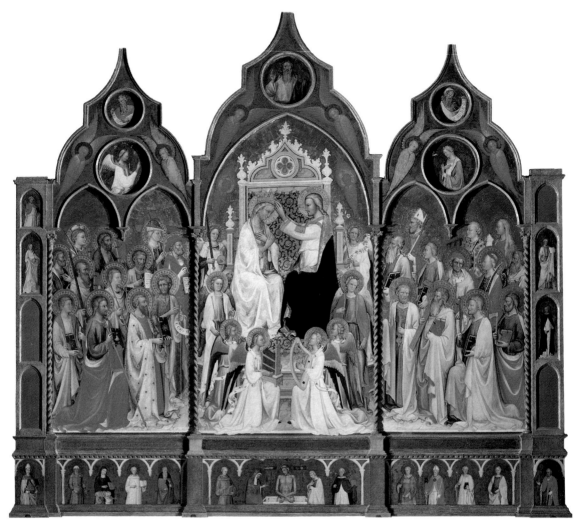

exhibit this powerfully dramatic masterpiece. Even despite the damaged condition of the painting one can discern the exquisite pictorial technique, the brilliant colours, the keen observation (see the cockerel).

In the same room there are works by artists we have already come across, such as Giovanni dal Ponte and Mariotto di Nardo. To conclude our visit to the first floor, and our tour of the Accademia as a whole, let us move to the last room, which documents the presence in Florence of the style known as International Gothic: the final expression of the Gothic world at the dawn of the Renaissance. This style was inaugurated, one might say, by the late activity of Agnolo Gaddi, the son of Taddeo, by whom there are two Madonnas on the end wall. Yet Agnolo died before the end of the fourteenth century. The two main characters of this culture in Florence were Lor-

enzo Monaco and Gherardo Starnina. On the lefthand wall there are two absolutely exceptional works by Lorenzo Monaco, in particular the celebrated *Annunciation* in the centre. Originally in the Badia Fiorentina and dating from 1410-15, it is almost a re-make—eighty years later—of the extremely famous *Annunciation* by Simone Martini, now in the Uffizi. The artist clearly takes up and develops themes from the French Gothic and from Giovanni Pisano's Italian Gothic world around the beginning of the fourteenth century and, performing a conscious operation of cultural revival, aims solely at creating almost musical rhythmical values. Aided in this by a very delicate colouring, it is the rhythm that brings the figures and the whole composition alive. The culmination of this sophisticated technique, which succeeds in giving an impression of improvisation whereas it is extreme-

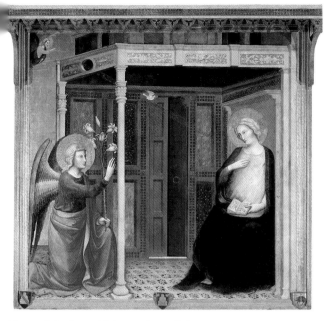

Master of the Straus Madonna: Annunciation

◁

Rossello di Jacopo Franchi: Coronation of the Virgin with Saints

▷

Niccolò di Pietro Gerini: Man of Sorrows with the Symbols of the Passion

ly carefully calculated, lies in the movements of the Angel and the Virgin. The almost cringing movement of the Madonna is expressed with such subtlety that it suggests both the action and its negation, investigating the profound psychological theme of the acceptance of the will of the Lord and of the fear in the face of this exceptional task. In fact one can say that it would have been impossible to go beyond this with these artistic premises (about seven years later, Masaccio's first work was to introduce a completely different relationship with reality).

Perfectly in line with these principles is also the little *Madonna* hanging next to it, as well as the three panels showing the *Crucifixion*, the *Virgin*, and *St John*. The predella in three panels that hangs below the round window that offers an exceptional view of the dome of Florence Cathedral is among the last (perhaps the very last) of Lorenzo Monaco's works. It is the predella for the large altarpiece commissioned by Palla Strozzi for the sacristy of the church of Santa Trinita; work on this altarpiece was interrupted, probably because of Lorenzo's death, when only the

cusps and the predella were finished. About ten years later, work was resumed by Fra Angelico, who painted one of his most impressive works, the *Deposition from the Cross* now in the Museum of San Marco. The separation of the predella from the altarpiece took place a long time ago, and in any case there would be no room to exhibit the predella together with the altarpiece in the Museum of San Marco today. The scenes show episodes from the lives of Saints Onofrius and Nicholas, with a *Birth of Christ* at the centre.

To the left of Lorenzo Monaco's *Annunciation*, a small panel showing the *Madonna and Child with Saints John the Baptist and Nicholas of Bari* is the work of the other great protagonist of Florentine Late Gothic art, Gherardo Starnina. It is only recently that schol-

85

Neri di Bicci: Coronation of the Virgin with Saints

▷

Russian school of the 16th century: Menology from September to February and from March to August

▷

Russian school of the 17th century: The Beheading of John the Baptist

▷▷

Russian school of the 17th century: The Madonna Enthroned

▷▷▷

Russian school of the 18th century: St Catherine

Neri di Bicci: Annunciation

ars have identified this almost mythical artist as the author of a group of works collected under the name of "Maestro del Bambino Vispo" (Master of the Lively Child). This was possible thanks to an operation of dating the works of this master in relation to the known and documented dates concerning Starnina, who died in 1413. Thanks to this research a large number of the events that took place in Florence in the first decade of the Quattrocento have become clearer: above all, we have discovered that the sudden flowering of International Gothic in the city coincided with Starnina's return to Florence, after several years spent in Spain. In this small altarpiece, bought by the Lorraine in 1781, we can discern the individualistic, almost extravagant style and modelling of the lines that move according to laws that are purely intellectual, entirely different from naturalism. See, for example, the clothing of the Baptist; so much so that the echoes of the art of Giotto in the early Trecento—in this case the references are to the *Ognissanti Madonna* in the Uffizi—seem almost ironical. As we said earlier these references were a constant element in a great deal of Florentine painting of the late fourteenth century. The few paintings that can be attributed to Starnina (and it now appears to be totally impossible to continue with the traditional

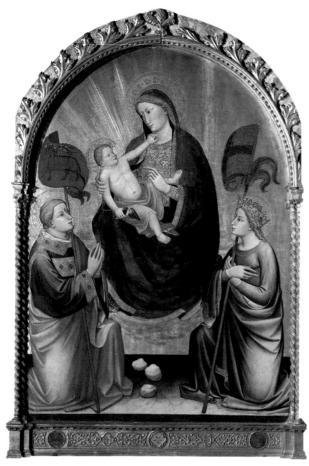

Mariotto di Nardo: Madonna and Child with Saints

Don Silvestro de' Gherarducci: Madonna of Humility and Angels

attribution to him of the *Thebaid* in the Uffizi; cf. the painting of the same subject by Paolo Uccello in the "Sale Fiorentine") show this perfectly gratuitous element, which is the hallmark of a courtly art, of a language widely spread throughout Europe, that linked the artistic styles of Spain, Germany, France, Bohemia, and so on. In this room we can see early examples of this artistic period (such as Agnolo Gaddi's Madonnas) and other expressions that belong to it directly (the works of Lorenzo Monaco, Starnina, his follower known as the Master of Borgo alla Collina, and the late works of the Master of the Straus Madonna); as well as some paintings which, although contemporary, have a complex attraction-cum-revulsion relationship with it, in some cases borrowing elements and adapting them to other basic stylistic principles (such as the Master of 1416, Giovanni Toscani, and Mariotto di Nardo himself).

Here ends our visit to the Accademia, an exceptional documentation of how the Florentine public collections were assembled.

Room 1

Giovanni Bonsi (?)
(Florence, documented in 1351, 1366 and 1370)
A Bishop Saint
Wood, 88x32 cm
Inv. no. 8701
From the convent of Santissima Annunziata in Florence.

Lorenzo Monaco
(Piero di Giovanni)
(Siena? c. 1370-Florence 1425)
Crucifix
Wood, 280x190 cm
Inv. no. 3147
From the Hospital of Santa Maria Nuova in Florence.

Giovanni Bonsi (?)
St Lawrence
Wood, 88x32 cm
Inv. no. 8702
From the convent of Santissima Annunziata in Florence.

Bernardo Falconi (?)
(Pisa, second half of the 14th century)
St Benedict Entrusts the Rule to St Romualdo
Wood, 44x77 cm
Inv. no. 3340
From the church of San Michele in Borgo in Pisa.

Mariotto di Nardo
(Florence, documented from 1394 to 1424)
Madonna and Child
Saint Lawrence and John the Evangelist
Saints Sebastian and James
Cusps: *Annunciation* and *Crucifixion*
Predella: *Stories from the Life of Mary*
Wood, 165x242 cm (central panel); 42x267 cm (predella)
Inv. nos. 3258-3260, 8612-8613
From the monastery of San Gaggio in Florence.

Bernardo Falconi (?)
St Romualdo's Dream
Wood, 44x77 cm
Inv. no. 3339
From the church of San Michele in Borgo in Pisa.

Niccolò di Pietro Gerini
(Florence, documented from 1368 to 1415)
Holy Trinity with Saints Francis and Mary Magdalen
Wood, 76x60 cm
Inv. no. 3944
From the convent of Santa Maria al Portico at Galluzzo near Florence.

Lorenzo Monaco and Bartolomeo di Fruosino
Crucifix
Wood, 220x190 cm
Inv. no. 3153

From the Hospital of Santa Maria Nuova in Florence.

Follower of Taddeo Gaddi
(Florence, c 1340)
Madonna and Child with Two Angels and Saints Lucy, Peter, Catherine and John the Baptist
Wood, 90x48 cm
Inv. no. Dep. 176
From the Chapel of the Crucifix in the church of Santa Maria degli Angeli in Florence.

Jacopo del Casentino
(Florence, late 13th century-post 1358)
St Bartholomew and Angels
Wood, 266x122 cm
Inv. no. 440
From the church of Orsanmichele in Florence.

Bernardo Daddi
(Florence, documented from 1312 to 1348)
Madonna and Child with Two Angels and Saints John the Baptist and Luke
Wood, 219x132 cm
Inv. no. 6170
From the palace of the Guild of Doctors and Apothecaries in Florence.

Room 2

Florentine painter of the early 15th century
Madonna and Child with Saints Francis and Antony
Wood, 77x41.5 cm
Inv. no. 8614
From the convent of Santissima Annunziata in Florence.

Niccolò di Pietro Gerini
(Florence, documented from 1368 to 1415)
Crucifixion
Wood, 244x135 cm
Inv. no. 4670
From the convent of Santa Maria degli Angeli in Florence.

Worshop of Lorenzo di Niccolò
(Florence, early 15th century)
Madonna and Child with Saints John the Baptist, Lawrence, Antony Abbot and James
Wood, 83.5x50 cm
Inv. no. 8578
From the church of Santissima Annunziata in Florence.

Giovanni del Biondo
(Florence, documented from 1356-died in 1398)
Presentation in the Temple; Saints John the Baptist and Benedict
Cusps: *God the Father*
Predella: *Stories from the Life of John the Baptist*
Wood, 215x186 cm
Inv. no. 8462
From the convent of Santa Maria degli Angeli in Florence.

Lorenzo Monaco: Pope St Caius

Andrea Orcagna (Andrea di Cione Arcangelo)
(Florence, documented from c 1343-died in 1368)
Pentecost
Wood, 195x287 cm
Inv. no. Dep. 165
From the high altar of the church of Santi Apostoli in Florence.

Niccolò di Pietro Gerini
Crucifixion with St Francis in Adoration and other Saints
Cusps: *Annunciation and God the Father*
Wood, 208x180 cm
Inv. no. 3152
From the church of the Hospital of San Giovanni

Battista called "Ospedale di Bonifacio" in Florence.

Spinello Aretino
(Arezzo c 1352-before 1413)
Madonna and Child with Saints
Wood, 109x209 cm
Inv. no. 8461
From the church of Sant'Andrea in Lucca.

Master of the Straus Madonna: St Francis and St Catherine

Niccolò di Pietro Gerini
Spinello Aretino
Lorenzo di Niccolò
(Florence, documented from
1392 to 1411)
*Coronation of the Virgin; Saints
Felicita and Andrew*
Predella : *Eight Busts of Saints*
Quadrilobes: *The Prophets
Jeremiah and Daniel*
Wood, 275x218 cm
Inv. no. 8468
From the high altar of the
church of Santa Felicita in
Florence.

Follower of Ambrogio di
Baldese
(Florence, active in the late
14th and early 15th centuries)
*Madonna and Child
Saints Catherine and Francis
Saints Zenobius and Mary
Magdalen*
Predella: *Birth of Christ, Stories
from the Life of St Catherine, St
Francis*
Wood, 190x273 cm (altarpiece);
40x280 cm (predella)
Inv. no. Dep. 18
From the convent of Santa
Maria degli Angeli in Florence.

Bicci di Lorenzo
(Florence 1373-1452)
*Madonna Enthroned with Angels
and Saints*
Wood, 198x245 cm
Inv. no. 3134
From the monastery of San
Francesco at Fiesole near
Florence.

Master of the Griggs
Crucifixion (Giovanni Toscani)
(Florence 1370/80-1430)
Doubting Thomas
Wood, 240x112 cm
Inv. no. 457
From the Soprasindacato della
Camera delle Comunità in
Florence.

Lorenzo Monaco
(Piero di Giovanni)
(Siena? c. 1370-Florence 1425)
Agony in the Garden
Wood, 222x109 cm
Inv. no. 438
From the convent of Santa
Maria degli Angeli in Florence.

Lorenzo di Bicci
(Florence before 1353-1427)
St Martin Enthroned
Predella: *St Martin and the Beggar*
Wood, 256x100 cm
Inv. no. Dep. 174
From the church of
Orsanmichele in Florence.

Giovanni del Biondo
*Annunciation, God the Father
Surrounded by Angels and Saints*
Cusps: *Crucifixion, Flagellation,
Resurrection*
Predella: *Man of Sorrows and Six
Saints*
Pilasters: *The Four Evangelists
and Four Prophets*
Wood, 406x377 cm
Inv. no. 8606
From the church of Santa Maria
Novella in Florence.

Giovanni del Biondo
St John the Evangelist Enthroned
Predella: *Ascension of John the
Evangelist*
Wood, 280x112 cm (altarpiece);
55x115 cm (predella)
Inv. nos. 444, 446
From the church of
Orsanmichele in Florence.

Lorenzo Monaco
*Madonna and Child with Two
Angels
Saints Bartholomew and John the
Baptist
Saints Taddaeus and Benedict*
Cusps: *Christ Blessing, the Angel
and the Virgin of the Annunciation*
In the pendentives : *Two
Prophets*
Wood, 274x259 cm
Inv. no. 468
From the monastery of
Monteoliveto near Florence.

Lorenzo Monaco
*Man of Sorrows with the Symbols of
the Passion*
Wood, 267x170 cm
Inv. no. 467
From a private collection.

Rossello di Jacopo Franchi
(Florence c 1377-1456)
*Madonna and Child
Saints John the Baptist and Francis
Saints Matthew and Mary
Magdalen*
Cusps: *St Peter, St Paul and the
Crucifixion*
Wood, 238x190 cm
Inv. no. 475
Provenance unknown.

Giovanni dal Ponte (Giovanni
di Marco)
(Florence 1385-after 1437)
*Coronation of the Virgin
Saints Francis and John the Baptist
Saints Ives and Dominic*
Cusps: *Annunciation, Descent into
Limbo*
Wood, 194x208 cm
Inv. no. 458
From the offices of the Monte
di Pietà in Florence.

Rossello di Jacopo Franchi
*Coronation of the Virgin with
Angels and Saints*
Cusps: *God the Father, Two
Prophets, the Angel and the Virgin
of the Annunciation*
Predella: *Man of Sorrows and
Saints*
On the pilaster: *Four Saints*
Wood, 344x300 cm
Inv. no. 8460
From the convent of the
Campora near Florence.

Master of the Straus Madonna
(Florence, active in the late
14th and early 15th centuries)
Annunciation
Wood, 190x200 cm
Inv. no. 3146
From the Leper Hospital of

Sant'Eusebio sul Prato near
Florence.

Lorenzo di Niccolò
*Madonna and Child
Saints Anthony Abbot and John the
Baptist
Saints Lawrence and Julian*
Wood, 178x264 cm
Inv. no. 8610
From the Camaldolensian
monastery of San Benedetto
outside Porta a Pinti, near
Florence.

Niccolò di Pietro Gerini
*Madonna and Child with Saints
John the Baptist and Zenobius*
Cusps: *The Redeemer Blessing*
Wood, 279x122 cm
Inv. no. 439
From the Registry Office,
Florence.

Bernardo Daddi
(Florence, documented from
1312 to 1348)
Crucifixion
Wood, 102x46 cm
Inv. no. 443
Provenance unknown.

Niccolò di Pietro Gerini
*The Man of Sorrows with the
Symbols of the Passion*
Cusps: *The Redeemer with Saints
James the Less, Thomas, Peter and
Dominic*
Predella: *The Funeral of a Brother
of the Pilgrim's Company*
Wood, 185x181 cm
Inv. no. 8720
From the church of Santa Maria
Novella in Florence.

Florentine painter of the late
14th century
*Madonna of Humility with Angels
and Saints*
Wood, 87x49 cm
Inv. no. 3156
From the Hospital of Santa
Maria Nuova in Florence.

Room 3

Above the door:
Bicci di Lorenzo
(Florence 1373-1452)
Mystic Wedding of St Catherine
Wood, 125x59 cm
Inv. no. 8611
Provenance unknown.

Florentine painter of the second
half of the 15th century
Holy Trinity with Saints
Predella: *Annunciation*
Wood, 205x93 cm
Inv. no. 3465
Provenance unknown.

Neri di Bicci
(Florence 1418-1492)
*Ascension of Christ with the Virgin,
the Apostles and Saints*
In the quadrilobes: *The Virgin of*

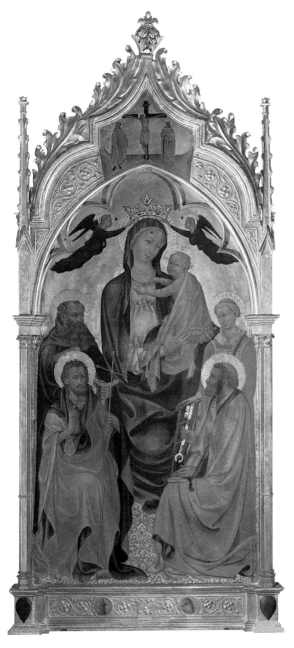

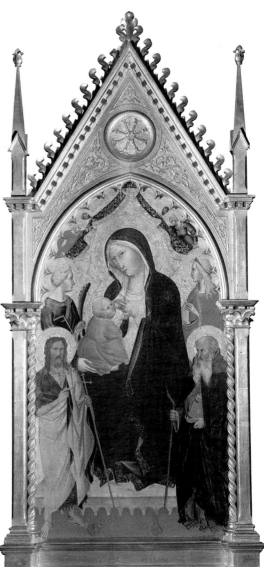

Agnolo Gaddi: Madonna and Child with Saints

◁
Master of Borgo alla Collina: Madonna and Child with Saints

the Annunciation
Wood, 198x245 cm
Inv. no. 8609
From the convent of Santa
Maria degli Angeli in Florence.

Neri di Bicci
Coronation of the Virgin with Saints
Wood, 222x232 cm
Inv. no. Dep. 13
From the church of San Felice
in Piazza in Florence

Neri di Bicci
Annunciation
Wood, 152x154 cm
Inv. no. 480
From the Compagnia
dell'Annunziata in the church of
Sant'Andrea in Mosciano near
Florence.

Neri di Bicci
*Saints Francis, Jerome, Philip,
Catherine and a Bishop (Albert the
Great ?)*
Wood, 130x89 cm
Inv. no. 3470
From the Villani Chapel in the
church of Santissima
Annunziata in Florence.

Neri di Bicci
*Coronation of the Virgin with Saints
Michael and Stephen*
Wood, 139x158 cm
Inv. no. 8618
From the convent of
Sant'Apollonia in Florence.

Neri di Bicci
Annunciation
Wood, 186x178 cm
Inv. no. 8622
From the convent of the
Campora in Florence.

Below:
Russian school of the 16th
century
*Menology from September to
February*
Wood, 70x54 cm

Inv. no. 5954
From the Guardaroba of the
Lorraine Granddukes.

Andrea da Candia
(active in Italy around the
mid-15th century)
*Madonna and Child with Two
Angels and the Symbols of the
Passion*
Wood, 103x84 cm
Inv. no. 3886
From the convent of San
Girolamo in Florence.

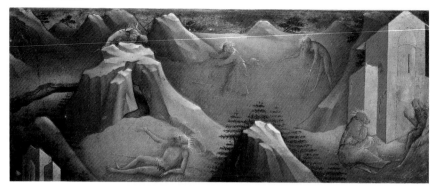

Lorenzo Monaco: Stories from the Life of St Onofrius

Agnolo Gaddi: Madonna of Humility

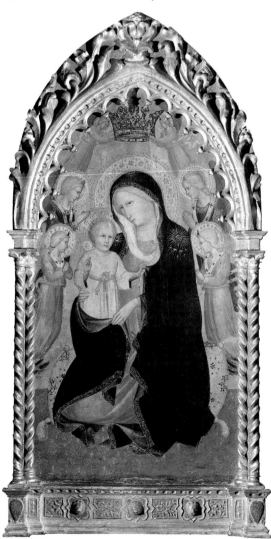

Russian school of the 16th century
Menology from March to August
Wood, 70x54 cm
Inv. no. 5955
From the Guardaroba of the Lorraine Granddukes.

Cretan-Venetian school of the 15th century
Madonna and Child with Archangels Michael and Gabriel in Adoration, Saints and Prophets
Wood, 60x57 cm
Inv. no., 431
Purchased on the international market.

Cretan-Venetian school of the 15th century
Saints Peter and Paul Present a Chapel to God
Wood, 53x41 cm
Inv. no. 9382
Purchased on the international market.

In the niches:
Russian schools of the 16th to 18th centuries
Icons
From the collections of the Lorraine Granddukes.

Mariotto di Nardo
(Florence, documented from 1394 to 1424)
Madonna and Child with Saints Reparata and Stephen
Wood, 161x118 cm
Inv. no. 3460
From the Palazzo dell'Arte della Lana in Florence.

▷
Lorenzo Monaco: Crucifixion

▷▷
Lorenzo Monaco: St John the Evangelist

Lorenzo Monaco: Madonna

Florentine artist close to Mariotto di Nardo
(Florence, early 15th century)
Madonna and Child

Around the lunette:
Giovanni dal Ponte
(Giovanni di Marco)
(Florence 1385-after 1437)
Annunciation
Wood, 114x134 cm
Inv. no. 450
From the Courthouse of
Florence.

Mariotto di Nardo
Madonna and Child
Saints Philip and John the Baptist
Cusps: *Two Angels*
Wood, 225x120 cm
Inv. no. 473
From the Hospital of Santa
Maria Nuova in Florence.

Bicci di Lorenzo
Saints Peter and Paul
Two Benedictine Saints
Two Apostles
Wood, 55x20 cm (each panel)
Inv. nos. 6141-6143
From the convent of Spirito
Santo in Florence.

Giovanni dal Ponte
St Helen and St James
Wood, 93x37 cm; 94x35 cm
Inv. nos. 8744, 8746
Provenance unknown.

Giovanni dal Ponte
St John the Baptist and St Francis
Wood, 136x68 cm; 138x66 cm
Inv. nos. 6094, 6103
From the convent of Santissima
Annunziata in Florence.

Don Silvestro de' Gherarducci
(Siena ? 1339-Florence 1396)
Madonna of Humility and Angels
Wood, 164x89 cm
Inv. no. 3161
From the convent of Santa
Maria degli Angeli in Florence.

Master of the Straus Madonna
(Florence, active in the late
14th and early 15th centuries)
*Man of Sorrows and the Symbols of
the Passion*
Wood, 226x110 cm

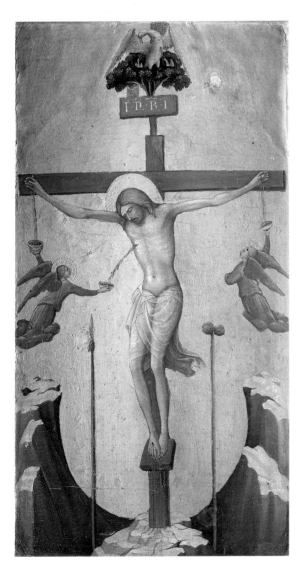

Inv. no. Dep. 14
From the Conservatory of San
Pietro Martire in Florence.

Lorenzo di Bicci
(Florence, documented from
1353-died in 1427)
Saints Julian and Zenobius
Wood, 114x38 cm (each panel)
Inv. no. 5410
Provenance unknown.

Florentine painter of the late
14th century
Saints Moses and John the Baptist
Saints Peter and Paul
Wood, 97/102x36/40 (each
panel)
Inv. nos. 8704, 8705, 8708,
8709
From the church of Santa Maria
del Carmine in Florence.

Bicci di Lorenzo
*Saints Andrew and Michael, Jerome
and Lawrence*
Wood, 145x58 cm (each panel)
Inv. no. Dep. 12
Provenance unknown.

Bicci di Lorenzo
St Lawrence
Wood, 236x84 cm
Inv. no. 471
From the Chamber of
Commerce, Florence.

Room 4

Lorenzo Monaco
(Piero di Giovanni)
(Siena? c. 1370-Florence 1425)
Pope St Caius
Cusp:
Lorenzo di Niccolò
(Florence, documented from
1392 to 1411)

The Angel of the Annunciation
Wood, 218x51 cm
Inv. no. 8604
From the church of San Gaggio
in Florence.

Lorenzo di Niccolò
St Catherine
Cusps: *The Virgin of the
Annunciation*
Wood, 216x51 cm
Inv. no. 8605
From the church of San Gaggio
in Florence.

Florentine painter (c 1430)
Madonna of Humility
Wood, 80x48 cm
Inv. no. 465
From the convent of Santa
Lucia in Florence.

Master of the Straus Madonna
(Florence, active in the late
14th and early 15th centuries)
St Francis
Wood, 56x23 cm
Inv. no. 477
From the church of San Jacopo
de' Barbetti in Florence.

Florentine painter of the early
15th century
*Christ on the Cross with the Virgin,
St Francis of Assisi and a Donor*
Wood, 60x41 cm
Inv. no. 3149
From the Hospital of Santa
Maria Nuova in Florence.

Master of the Straus Madonna
St Catherine
Wood, 56x23 cm
Inv. no. 476
From the church of San Jacopo
de' Barbetti in Florence.

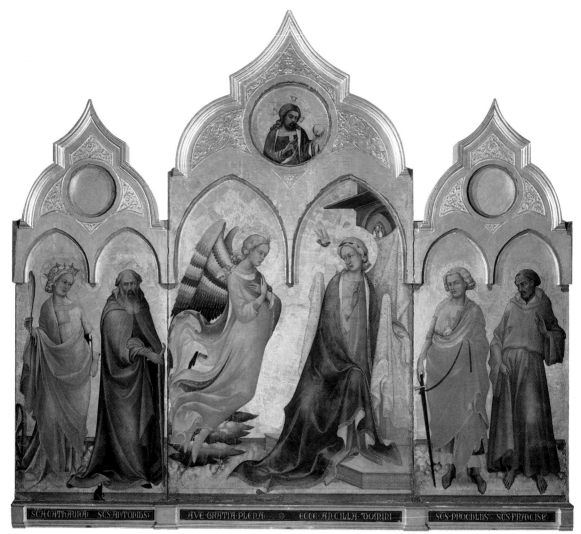

Mariotto di Nardo
(Florence, documented from
1394 to 1424)
Annunciation
Wood, 137x136 cm
Inv. no. 463
From the church of San
Remigio in Florence.

Florentine painter of the late
14th century
Christ Imparting His Blessing
Wood, 88x35 cm
Inv. no. 3221
From the Hospital of Santa
Maria Nuova in Florence.

Master of Borgo alla Collina
(Florence, early 15th century)
*Madonna and Child with Saints
Anthony Abbot, Francis, Catherine
and Lucy*
Wood, 120x57 cm
Inv. no. 3159
From the Hospital of Santa
Maria Nuova in Florence.

Master of Borgo alla Collina
*Madonna and Child with Saints
Anthony Abbot, John the Baptist,*

Lawrence and Peter
Cusps: *Crucifixion and Saints
Sebastian and Julian*
Wood, 179x80 cm
Inv. no. 478
From the Tax Offices in
Florence.

Agnolo Gaddi
(Florence, documented from
1369-died in 1396)
*Madonna and Child with Saints
Catherine, John the Baptist, Mary
Magdalen and Anthony Abbot*
Wood, 87x51 cm
Inv. no. 8577
From the convent of Santissima
Annunziata in Florence.

Lorenzo Monaco
*Stories from the Life of St Onofrius
Birth of Christ
A Miracle Performed by St
Nicholas*
Wood, 26x58/61 (each panel)
Inv. nos. 8615-8617
From the church of Santa
Trinita in Florence.

Agnolo Gaddi
Madonna of Humility
Wood, 118x58 cm
Inv. no. 461
From the convent of Santa
Verdiana in Florence.

Lorenzo Monaco
*Madonna
St John the Evangelist
Crucifixion*
Wood, 50x46, 50x46, 59x39
cm
Inv. nos. 2140, 2169, 2141
From the convent of San
Jacopo de' Barbetti in Florence.

Lorenzo Monaco
*Madonna and Child with Saints
Catherine and John the Baptist, a
Martyred Saint and St Peter*
Wood, 89x49 cm
Inv. no. 470
From the Toscanelli Collection.

Lorenzo Monaco
*Annunciation and Saints Catherine,
Anthony, Proculus and Francis*
Wood, 210x229 cm
Inv. no. 8458

From the church of the Badia
Fiorentina; originally from the
church of San Procolo.

Gherardo Starnina
(Florence, active in the early
15th century-died in 1413)
*Madonna and Child, Angels and
Saints John the Baptist and Nicholas*
Wood, 96x51 cm
Inv. no. 441
Provenance unknown.

Giovanni Toscani
(Florence 1370/80-1430)
*Stigmatization of St Francis and a
Miracle Performed by St Nicholas*
Wood, 28x56 cm
Inv. no. 3333
From the Ardinghelli Chapel in
the church of Santa Trinita in
Florence.

Giovanni Toscani
*Madonna and Child with Saints
Stephen and Reparata*
Wood, 148x102 cm
Inv. no. 5919
Provenance unknown.

94

Index of illustrations

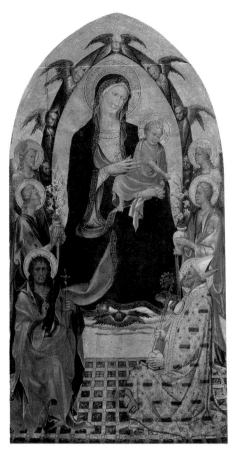

Gherardo Starnina: Madonna and Child with Angels and Saints

◁

Lorenzo Monaco: Annunciation with Saints

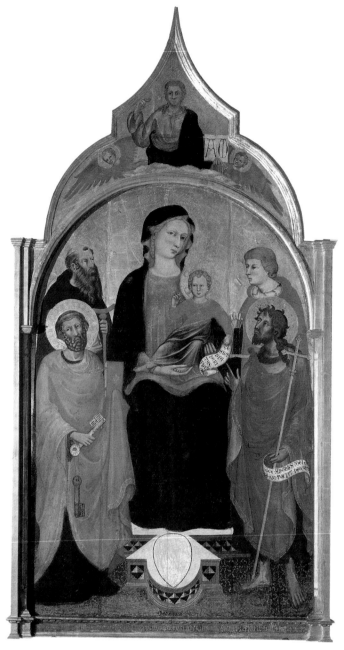

Master of 1416: Madonna and Child with Saints

Master of 1416
(Florence, early 15th century)
Madonna and Child with Saints
Anthony Abbot, Peter, Julian and
John the Baptist
Cusp: *God the Father*
Wood, 231x115 cm
Inv. no. 4635
From the Chamber of
Commerce, Florence.